AN INTRODUCTION TO
PAINTING FLOWERS

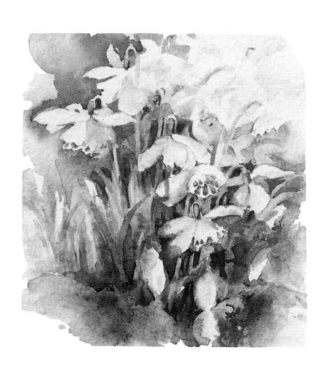

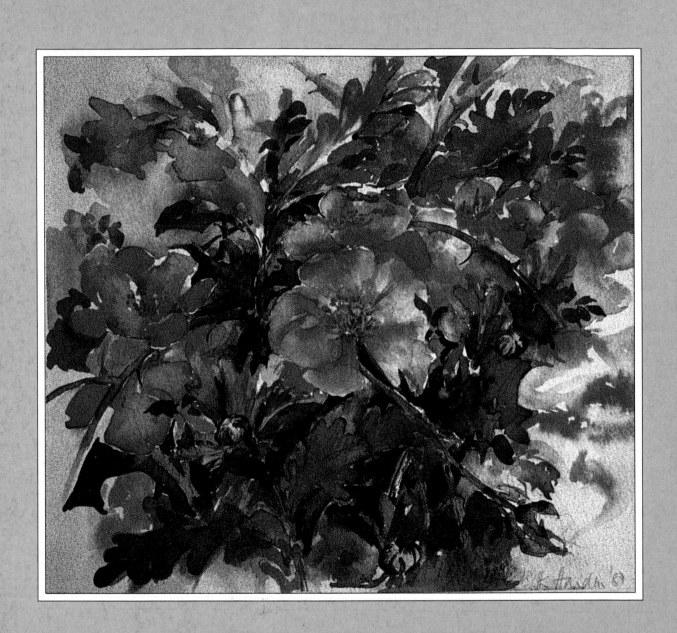

AN INTRODUCTION TO
PAINTING FLOWERS

FORM · TECHNIQUE · COLOUR · LIGHT · COMPOSITION

ELISABETH HARDEN

THE
APPLE
PRESS

A QUINTET BOOK

Published by The Apple Press
6 Blundell Street
London N7 9BH

ISBN 1–85076–536–7

This book was designed and produced by
Quintet Publishing Limited
6 Blundell Street
London N7 9BH

Creative Director: Richard Dewing
Designer: Ian Hunt
Project Editor: Helen Denholm
Editor: Geraldine Christy
Photographer: Jeremy Thomas

With special thanks to Artworker, Brighton,
for providing materials for photography.

Typeset in Great Britain by
Central Southern Typesetters, Eastbourne
Manufactured in Singapore by Bright Arts Pte. Ltd.
Printed in Singapore by Star Standard Pte. Ltd.

CONTENTS

INTRODUCTION

Flowers are a symbol of love and life, freshness and vigour. To paint them is the ultimate pleasure. Flowers offer to the painter a subject of the utmost variety in a form that is part of our everyday life, not only in garden and countryside, but adapted into designs and patterns. Ceramics, textiles and advertising all make use of this simple image. The flower is a constant and compelling source of inspiration.

The overwhelming quality of flowers is that they live and breathe. The painter meets them at a particular point in their life cycle and tries to capture that instant. Each describes it in his or her own particular way – a carefully observed study of a single flower in a jam jar can be as potent an image as a swirling explosion of brilliantly coloured blooms. Each image is the individual expression of the painter, a response to shape or colour or mood.

As a subject, flowers have obvious advantages; the range is vast, the cost minimal. Exotic azaleas, once only accessible after months of trekking into the Himalayas, can be bought easily on any high street corner. Landscape and portraiture have their own specific problems, but a flower composition can be instantly set up in the corner of a room with a few roadside flowers, arranged at will and painted at leisure.

There are less obvious benefits – longer contemplation and closer investigation of flowers will uncover shapes and colours and hidden landscapes unimaginable at first glance. Painting flowers is a journey of exploration travelled by some of the greatest painters in history. Close observation reveals the personality of a plant, the gestures it makes and the detail that gives character to the whole. Looking also makes you aware that

BELOW **These beautiful poppies by Rosemary Jeanneret capture fully the delicacy of the petals and stems.**

what you are seeing is not what you think you see, that a leaf presenting itself to you at an acute angle is not the expected oval but a thin triangle, that a white flower against the light becomes in part dark grey.

The principal purpose of this book is to encourage you to develop these skills of observation, to offer basic information on materials and technique, and to show how different artists compose, create and arrive at a finished painting. The ways of applying paint are limitless. Experimenting with different materials and exploring new methods can trigger fresh ideas and fire the imagination. The ultimate aim is to instil an urge in you to pick up a brush and confidently put into paint an interpretation of the vision that is in us all.

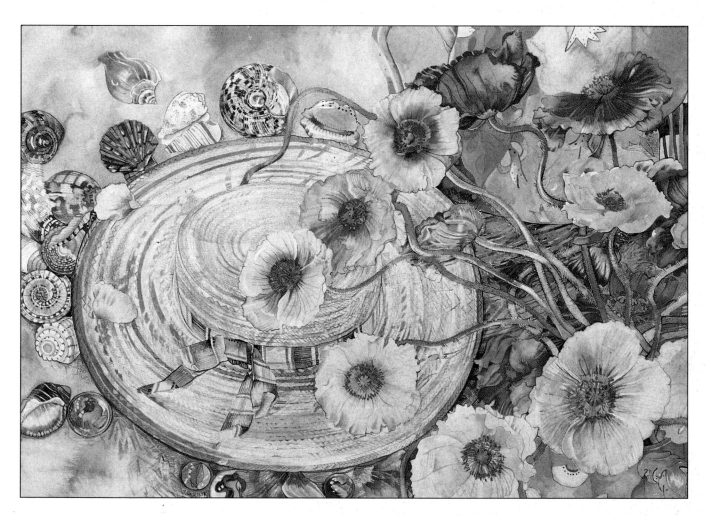

1
FLOWER PAINTING IN HISTORY

F lowers have been painted from the earliest times, ever since man first began to represent the forms he observed in nature. Basic shapes of trees and plants were daubed on cave walls in colours made from burnt sticks and coloured mud. Images of flowers and plants decorated the tombs of Egyptian Kings and nobles to enhance their life after death. The lotus and papyrus were the source of decorations of all kinds.

Early societies like those of the Minoans, Greeks and Romans painted flowers as a record of sources of food and medicine, and long periods of social stability enabled botanical art to flourish. Then came the collapse of the Roman Empire and chaos. The thread of botanical knowledge was carried by Arabic scholars who copied and re-copied old manuscripts, and it re-emerged in the monastic world many centuries later. Monks drew inspiration from their gardens to create floral jewels to enrich manuscript borders for the glory of God.

The thirst for knowledge was one of the principal features of the Renaissance. Scientists and artists alike set about investigating the nature of things, and in Leonardo da Vinci the two disciplines were combined. As a scientist Leonardo studied, among other things, phyllotaxy, or the arrangement of leaves on a stem; as an artist and draughtsman he tried to capture in drawing the energy of life force, for he believed that "Nature rather than man had the key to the Universe".

At the same period, Albrecht Dürer in Germany produced watercolour studies that are breathtaking. Most people are familiar with his study of a clod of turf with plantain leaves, sagging dandelion heads and spiky grasses. This was painted after Dürer had spent a long period of illness indoors – it was perhaps his spontaneous reaction to growing things and to the vigour of life.

In the East, flower painting had been practised for thousands of years and had developed a different identity – less concerned with botanical exactitude, more with aesthetics, symbolism and the quality of life. Sweeping brush strokes captured the essence of the

A B O V E **Flowers were used for the border decoration of manuscripts. They were painted in meticulous detail and are somewhat formal in design. Opaque pigments were used, sometimes derived from the flowers themselves. This beautiful border painted around 1500 in watercolour by an unknown Flemish artist is from the Victoria and Albert Museum, London.**

R I G H T *The Great Piece of Turf* by **Albrecht Dürer was completed in 1502 and hangs in the Albertina, Vienna. The worm's eye view of a clod of meadow turf shows his ability to combine close scientific analysis with a creative and tender response to the wonders of the natural world.**

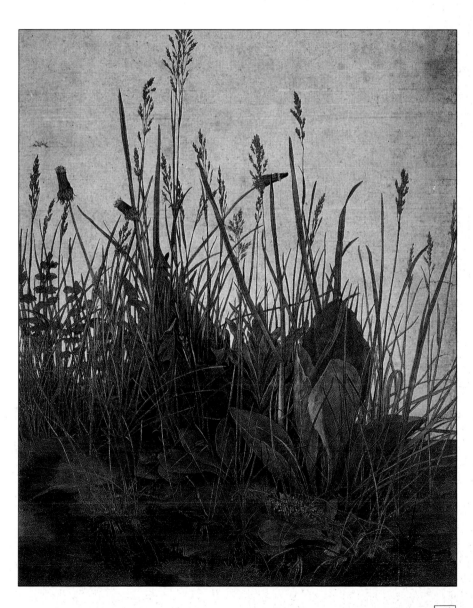

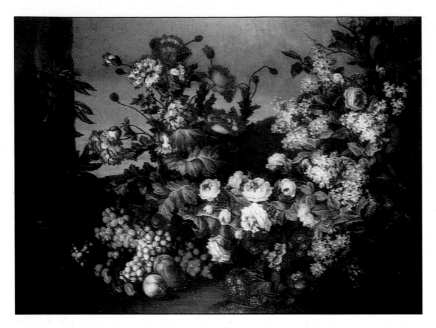

living plant. The techniques were part of everyday life; skills with brush and ink were acquired at an early age and developed to the point where a whole branch could be described in one elegant, dextrous sweep of the brush.

With the arrival of traders and explorers, East and West met. When examples of this highly developed and radically new style of flower painting arrived in Europe, the impact was enormous. The fluid simplicity of Japanese and Chinese art, and the wealth of detail and pattern developed by Indian and Persian artists was, and continues to be, an inspiration to artisans of all kinds, not least painters.

The same degree of artistic wizardry was achieved in the

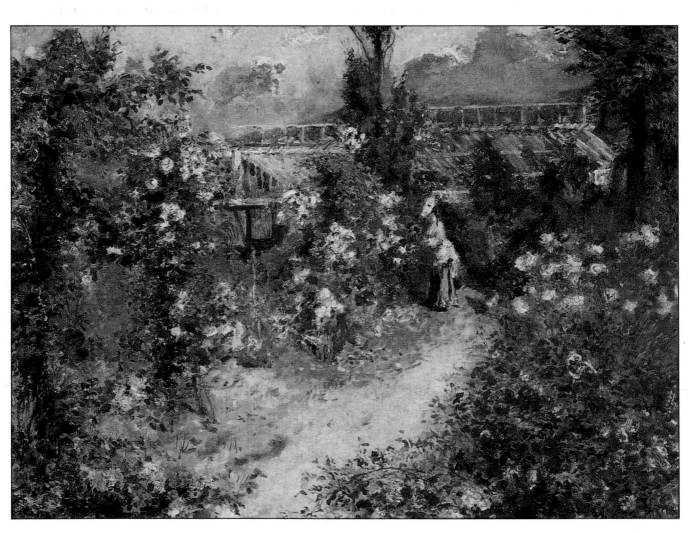

Netherlands in the 17th century, though the style and motive could not have been more different. Freed from the constricting Spanish Catholic influence and blessed with enormous economic prosperity, rich merchants demanded showy flowers such as rare tulips rather than the more modest herbs around at the time, tracked them down to the four corners of the globe and encouraged artists painting them to greater and greater heights of artistic dexterity. This was the supreme period of flower painting – art for the appetite.

Botanical art flourished in the centuries that followed. Gardens were created and no expedition travelled without its own artist. The wealth of new plants collected was recorded by some of the finest botanical artists of all time, names like Bauer and Redoute, and engraved and printed images of these newly discovered plants became available to a wider audience. Later, as travel became easier, there were also amateur travellers, wealthy enthusiasts who travelled the world fearlessly and recorded its flora with an enthusiastic wonder.

In the 19th century flower painting developed in new directions. For the French Impressionist painters the natural world was a source of untold riches. Flower studies were part of their investigation of colour – paintings of gardens and landscapes were used as a means of expressing their impressions of light. These artists reaped the rewards of great technological progress. Many new colours were developed, the invention of paint tubes meant that artists could paint outside their studios, and the development of the flat brush ferrule enabled paint to be dabbed and stroked into animated,

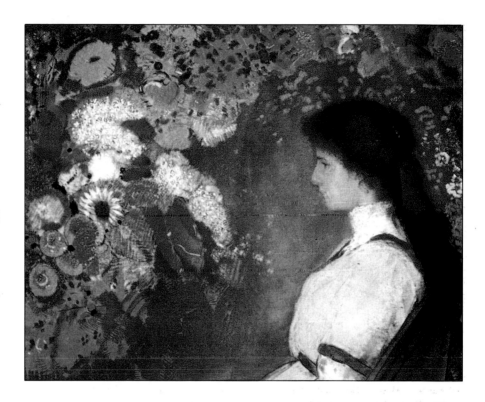

A B O V E **Odilon Redon's flowers are blossoms of the imagination. In** *Portrait of Mademoiselle Violette Hayman* **the profile of a young girl is set against a panoply of brilliant colour.**

expressive textures. The results were revolutionary and the fruits familiar to all – Monet's paintings of his garden and ponds, full of flickering light and huge sweeps of colour, Odilon Redon's dream-like flower studies and portraits, and Renoir's soft hazes of massed flowers. Van Gogh painted numerous studies of flowers as explorations of colour, including the series of brilliant yellow sunflowers to decorate his house in Arles for Gauguin's visit.

The 19th century was also the age of the great American flower painters, expressing visually the natural wonders of the New World; of the Pre-Raphaelites, seeking, in minute botanical detail, the purity of a lost age of gold; and of the artists who were part of the Arts and Crafts Movement, trying to abstract the linear vigour of plant growth and

adapt it into design. "Art is the flower – life is the green leaf" was a principle followed by artists such as Charles Rennie Mackintosh whose close studies of plant form were adapted into a stylistic code of design and translated into fabrics, furniture and buildings.

Flowers have been painted for so many purposes and in so many ways; everyone has their own particular favourites – often in the form of dog-eared reproductions religiously treasured. It pays dividends to look afresh at flower paintings we love, or those whose image has stuck in the mind. It is an invaluable exercise to study what makes a painting work for you. Is it the vigorous texture of paint, or colours coming together with an explosive zing, or the way the subject is composed and how and why the eye is led to certain parts? By analysing what appeals in "past masters", we can more readily negotiate a path to our own artistic expression.

MATERIALS AND EQUIPMENT

A successful flower painting depends in part upon choosing an appropriate medium. Each has its own distinctive qualities. The delicacy and translucency of watercolour is well suited to capture the transient character of flowers and to create a soft haze of colour, while the curious patterns and unpredictable merging of paints give a feeling of movement and life. Gouache tends to be more solid, lending itself to pattern and shape. Oil paint is rich and vibrant – the perfect medium for vigorous brush work, or flickering dabs of paint. The basic advice is that you should feel confident and comfortable with the medium you choose, that you should continue to explore and build up a knowledge of the materials available and a proficiency in their use.

In technical terms, painting is the manipulation of ground pigment in a binding medium, on a receptive surface, by an appropriate tool – a rather clinical description that gives little hint of the vast range of brushes, papers, colours and other materials developed by artists' manufacturers over the centuries. But a great deal can be accomplished with the minimum of materials, and it is a good idea to start off with a few good quality basic brushes and paints rather than to spend a great deal of money on an extravagant collection you may never use.

USING WATERCOLOUR AND GOUACHE

Paints

Most painters remember the excitement of receiving a huge rainbow box of paints and the frustration of desperately rubbing a stubby black brush into a little lozenge of paint and finding that little colour appears on the paper. In watercolour, more than any other medium, price reflects quality – quality means glow, transparency and, to a certain extent, permanence.

Watercolour consists of extremely finely ground pigment mixed with a binder. It is the oldest painting medium – originally natural earth, soot or chalk, bound by gum, starch or honey. Nowadays it consists of natural or chemical pigment, mixed with gum arabic and a little glycerin as moisturizer. The different characteristics of the pigment add to the excitement – some earth colours granulate, stay on the surface, and separate from others; some

BELOW A selection of watercolour and gouache materials including a box of half pan watercolour paints, some tubes of gouache, a fine sable and a medium flat brush. Also shown are gum arabic, which can be used to thicken paint and produce a slight sheen, and masking fluid, which will reserve white or pale-coloured areas when washes are applied.

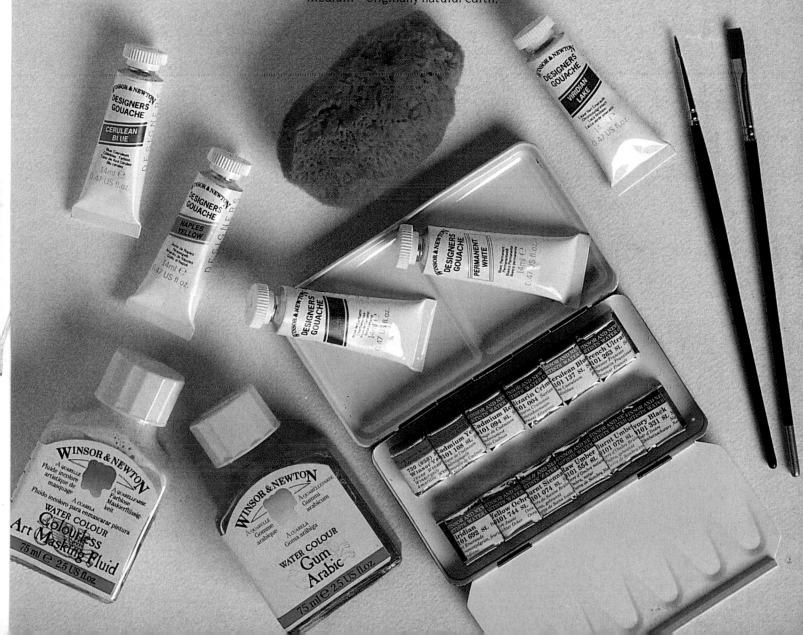

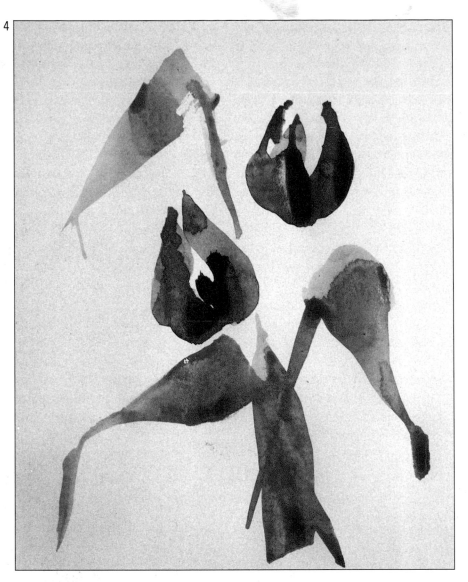

3 Flat brushes make fine lines when used along their narrow edge, can be twisted to make very wide marks and then trailed to a point. This is a 2.5cm (1in) synthetic brush making these marks in one stroke.

4 Other leaves have been formed with the wide brush, sometimes using different colours on each angle of the brush tip.

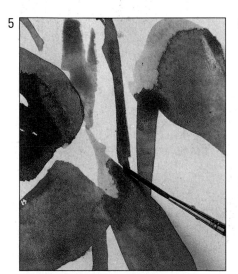

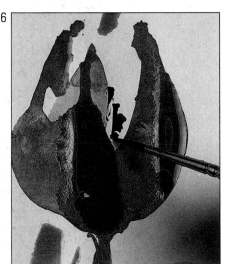

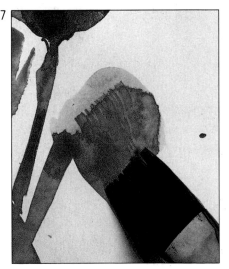

5 A well-loaded rigger brush forms the stems. Riggers hold more paint than the equivalent short-bristled brush and are useful for fine lines and trailing shapes.

6 For detailed work the delicate point of a fine size 2 sable can accurately pinpoint paint into specific areas.

7 Fairly dry paint is stroked onto the leaf with a dryish flat brush.

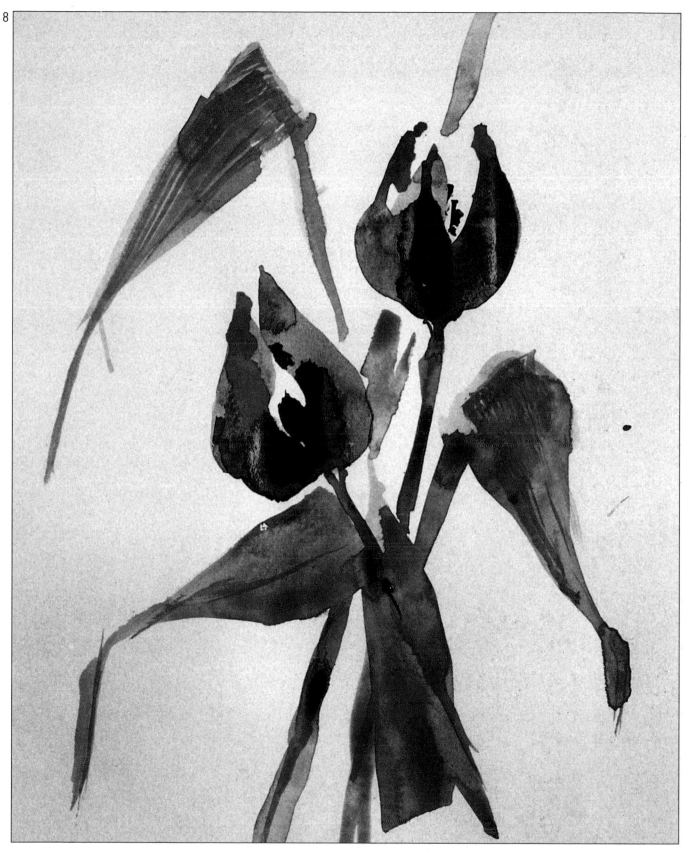

8 The completed picture – a simple
demonstration exercise that succeeds in
producing an effective image.

Papers

Papers come in a wide range of quality and price. It is worth investigating the paper trays in a good art shop to get an idea of what is available and to ask for advice from staff, who are often artists themselves.

Cartridge paper, a wood-pulp based, strong paper, originally used to hold a small charge of powder for a firearm, is good for sketching and planning, for rough work and for acrylics.

Watercolour paper, made from linen and cotton rag in various proportions, and made with acid-free water for permanence, comes in three categories – Rough, Cold Pressed Paper known as NOT for Not Hot Pressed, and HP for Hot Pressed. Hot pressed is used mainly for line and wash and fine botanical drawings. Its very smooth surface, while ideal for flowing pen lines, is slippery for paint. Cold pressed is the best all-round paper. The texture is smooth enough for detailed work while having enough "bite" to hold large washes, and enough roughness for lively, dry brush strokes. Rough paper can be found with different "tooth" marks, the minute bumps and hollows that bite the paint off the brush. With a dry brush, paint stays on the hills, and with a wet brush it slips into the hollows.

Papers come in different weights and absorbencies. The weight is expressed as pounds per ream (480 sheets) or grammes per square metre. Lightweight papers 150–300gsm (70–140lb) will need to be stretched, while heavier papers 300–555gsm (140–260lb) can be clipped to a board for small work but are better stretched for very large work or heavy washes. Heavyweight papers, up to 640gsm (300lb), do not need to be stretched and can cope with plenty of water and vigorous handling.

The absorbency of a paper, dictated by the "size" or sealing agent, can produce interesting effects. On the one extreme, paint sinking and spreading in blotting paper can result in an attractive haziness, and can produce frilled edge lines round pools of paint on semi-absorbent paper. For the beginner a paper with little absorbency is the easiest to work on – paint spreads more fluidly and colour can easily be removed from the surface.

A good starter pack would consist of some large cartridge paper, a medium-sized sketch book and a pocket book for ideas, some sheets of 190gsm (90lb) cold pressed paper of a quality able to stand up to erasing and heavy washes, and perhaps some tinted paper for gouache.

BELOW Some of the many types of paper available for watercolour. From left to right Fabriano Artistico Rough, Bockingford Tinted, Arches HP, Saunders Waterford NOT and Bockingford NOT. The brushes surrounding the watercolour mixing palette are, from left to right, Chinese flat brush or hake, size 0 sable, rigger, size 7 sable, Chinese brush, size 16 acrylic brush and a squirrel hair brush.

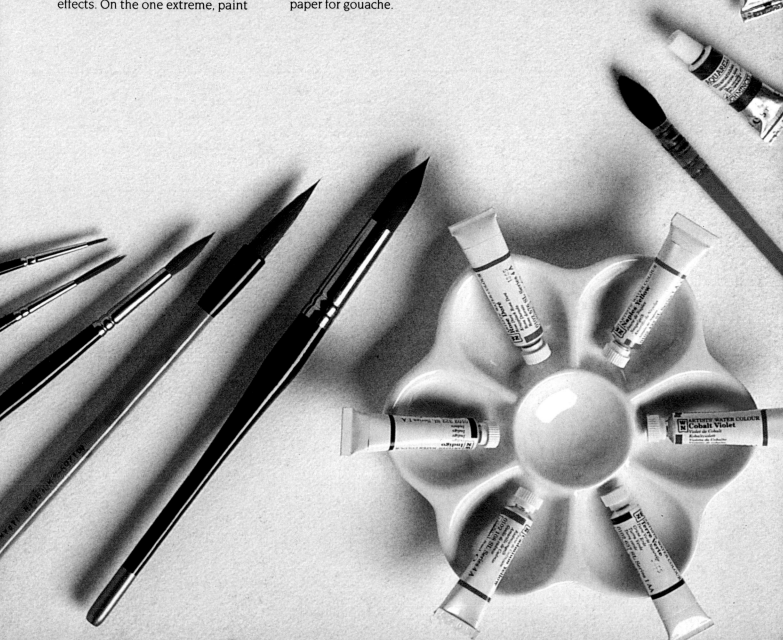

STRETCHING PAPER

When you are using watercolour it is important to stretch the paper in preparation for painting.

The sequence of pictures below explains how this should be done.

1 Find the right side of the paper by holding it up to the light – the watermark should read correctly on the right side. Soak it briefly.

2 Lifting the paper out by one edge, shake it gently to get rid of any excess water.

3 Carefully lay the wet paper right side up on the drawing board, making sure that you do not trap any air under the paper and that the paper is completely flat.

4 Cut strips of gummed paper and dampen them with a sponge.

5 Stick all four sides of the paper to the drawing board with the gummed paper. Secure the paper firmly with drawing pins pushed into each corner of the paper, and leave the paper to dry naturally, away from any source of heat.

Other equipment

A good palette for mixing paints is essential and also two flat-bottomed water jars, one for clean water and the other for washing brushes. These should be shallow enough for the brush to go in easily, and made of glass so that you can keep an eye on the state of the water. Other items that are essential are a hairdrier, to speed up drying and push the paint around, and a selection of tools for manipulating the paint – a sponge, toothbrush, twigs or tissues.

USING ACRYLIC

Paints

Acrylic paint is a supremely adaptable medium, developed early this century by a group of Mexican artists seeking a more versatile, durable and quick-drying medium for murals, frescoes and restoration. Ground pigment is dispersed and suspended in acrylic resin, a polymerized resin binder, and can be manipulated thickly like oil or diluted with water or a special medium and used as watercolour. It dries quickly to a waterproof, luminous, matt or gloss finish. The speed of drying is both an advantage and a disadvantage. Layers of paint can be built up quickly, clean, sharp lines made as colours butt each other, and lively textures pulled out of the rapidly drying paint. It is ideal for painting fine details on a dark background, such as cactus spines, or flower stamens. However, the quick-drying paint also means that mistakes can be hard to remedy as it does not allow for paint to be reworked except by overpainting.

Most manufacturers make a good range of acrylic paint. Liquitex makes acrylic paint in various forms. Some names of colours are recognizable by names common to oil and watercolour, but extensive research has produced new chemical formulae and new names.

LEFT A selection of acrylic colours, and one of a range of media available for diluting the paint.

Brushes and supports

Acrylic paints take their toll on brushes. The harsh, stiff paint can wear out the bristles, weaken the ferrule that holds the bristles and transform the brushes into rigid palm trees unless they are instantly washed in warm water. If they are irretrievably rigid, soak overnight in methylated spirits and wash in warm, soapy water. Acrylic is a good medium for old watercolour brushes.

The delight of acrylic paints lies in their versatility. As a support almost anything is suitable – wood, paper, sanded metal, primed walls, canvas; illustration board is excellent. A good range of colours is available in most art shops, and from the wide range of additions on the shelves, an acrylic primer, a medium and a retarder are essential, plus a good-sized mixing palette. Acrylic paint has a firm texture and needs vigorous mixing to dilute. Speedy cleaning up of everything, not only of brushes, is important – paint on plastic palettes will peel off, but it is a tough medium and sticks limpet-like to anything.

USING OIL

Paints

Oil painting was traditionally the medium for painting flower compositions, and watercolour the preferred medium for botanical studies. The rich colours of Dutch still lifes was achieved by applying layer upon layer of transparent colour. Oil paint brings particular qualities to flower painting. It is adaptable and can be moved around the canvas, brushed, scraped, and manipulated with a palette knife to make a textured surface with a rich, lustrous finish.

Oil paints, which come in students' and artists' quality, are made from ground pigment bound with linseed or poppy oil. As with watercolours, a vast number of colours is available, but a selection of basic colours will mix to a very effective range. Most flower and leaf colours can be mixed from the following: titanium white, lemon yellow, cadmium yellow, yellow ochre, cadmium red, cadmium red deep, alizarin crimson or rose madder, chrome green, viridian and burnt umber.

Each painter finds his or her own palette pattern and becomes familiar with it, so that a brush can go automatically to a particular colour. The pattern often corresponds to the colour wheel or, basically, the rainbow and is generally set out with blobs of paint surrounding the central mixing area. It is important to keep this area fairly clear and the paints clean; a rogue streak of red when painting a white petal can be disastrous.

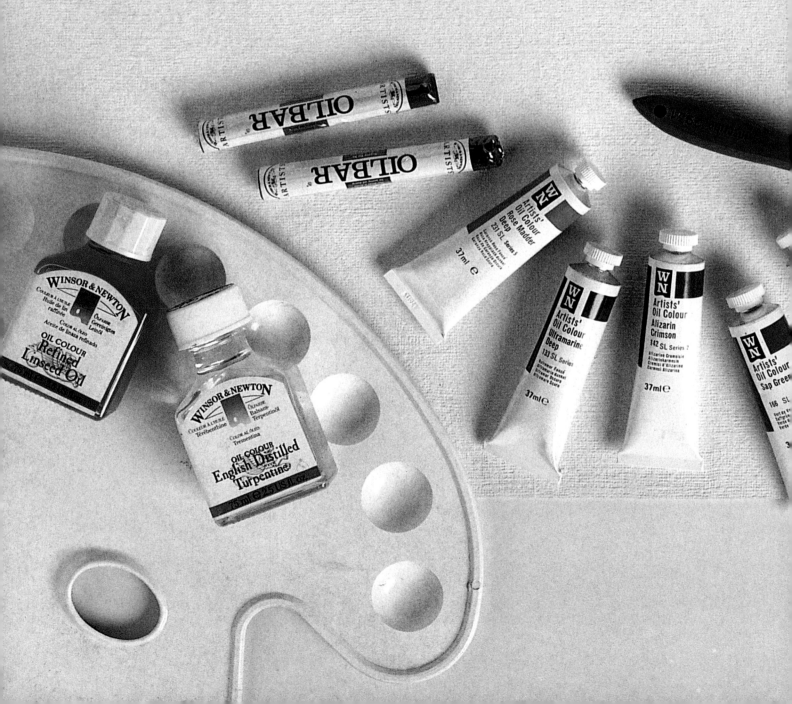

Oil paint is now available in stick form. These bars are easy to use and versatile – try them for laying out a composition, creating texture, or making vigorous drawing strokes in a surface wetted with turpentine.

Oil paints are mixed with a medium, a mixture of distilled turpentine and linseed or poppy oil – 1 part oil to 3 parts of turpentine is a good mix but most painters develop their own recipes. This thins the paint to the required consistency, or it can be used straight from the tube.

Brushes

As with paints it is false economy to make do with cheap brushes. Oil painting brushes are generally made from bleached hogs hair, which has split ends to hold the paint, or synthetic fibre. They come in three basic shapes – round, square and filbert – and a variety of sizes. Sable brushes give a smooth line and are useful for detailed work but are expensive, and soft badger brushes are sometimes used for blending colour. Keep white spirit and a rag nearby to keep your brushes clean.

B E L O W A selection of oil painting materials. Both acrylic and hog hair brushes are shown in a variety of shapes and sizes. The range, from a size 1 round to a size 8 flat, is versatile enough for most occasions. The fan brush feathers wet paint and blends colours.

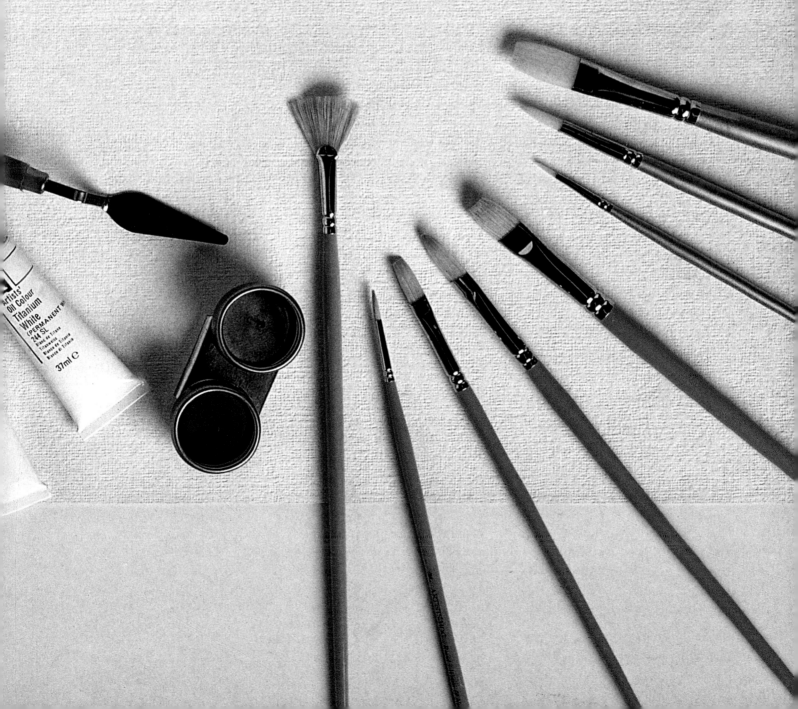

Painting pictures is mostly about ideas, but a knowledge of technique equips you with a visual vocabulary, and a springboard for discovering your own methods of working. Trying some of the different methods of using paint is exciting, and an unexpected result can become the basis of a spontaneous painting.

WATERCOLOUR

Additives

Gum arabic added to the water used for mixing paint will give a denser colour and a firmer texture. Ox gall (literally the gall of an ox – now happily available in prepared form) reduces surface tension and allows the paint to spread freely.

Back runs

Slightly wetter paint, worked into a wash before it is dry, will spread into random shapes with hard, serrated edges. It is a distinct characteristic of watercolour. Back runs can also be created and manipulated with a hairdrier by blowing the paint in various directions, and also by tipping the painting board and allowing the paint to flow back over itself. It can be a most useful device in flower painting – blown trickles of paint can create leaves and petals.

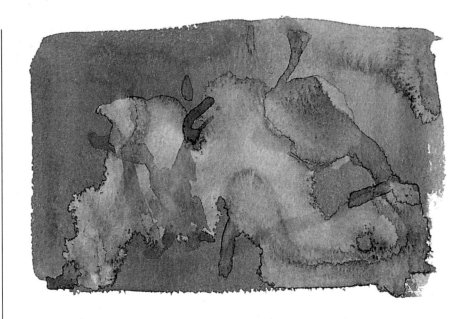

ABOVE Back runs created by dropping slightly wetter paint into a wash and manipulating it by tipping the board or blowing with a hairdrier.

BELOW Paint lightly brushed over paper with a dry brush will produce this lined effect.

Dry brush

A bristly texture or lined effect can be obtained by splaying a fairly dry brush, loading it with a minimum amount of paint and dragging it over the paper at an upright angle. Experiment on rough paper to gauge the exact degree of dryness, amount of paint and the type of bristle to use. Stiff, longer hog hair generally works well, as does a flat brush with the bristles spread between finger and thumb. Use this effect sparingly – it is most appropriate for grasses, texture on petals and bark, and sharpening up a landscape foreground.

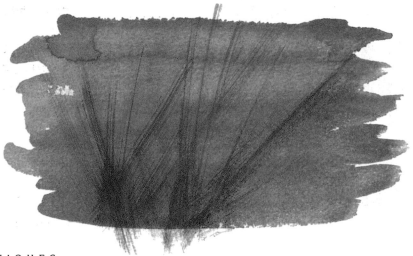

Hard edges

When a puddle of paint is dropped onto dry paper, the pigment tends to collect towards the edges causing a hard line. The strength of this colour can be increased by pushing or blowing the paint into this edge. This hard-edged effect can sometimes be frustrating when unwanted lines of paint appear because the paper has dried too quickly, but it can be remedied by gently nudging the paint lines with a damp brush or sponge. More often, however, it is a wonderful technique, creating natural petal and leaf shapes.

Wash over wash, leaving different areas dry, will create a web of flowing lines, which can be used to suggest shapes and add depth to a painting.

RIGHT **Several layers of wash have been applied here, leaving different areas dry in each case, the result being this mesh of flowing lines.**

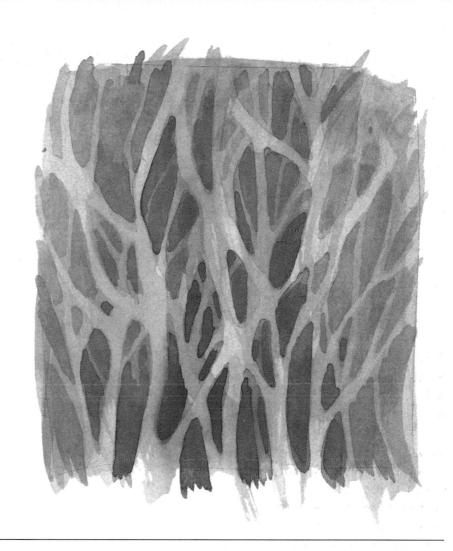

Lifting out

Removing paint to bare the light paper beneath is another possibility. A sponge, crumpled tissue paper or blotting paper, cotton bud or stiff brushes can be used to lift wet paint from the surface and make a soft-edged shape. Paint can also be lifted out when dry. Water dropped or stroked into strong colour pushes edges back and can be mopped out to form paler stems and veins. Obviously a lightweight paper will cope less well with vigorous "lifting out".

LEFT **A stiff brush has been used to remove areas of paint, leaving soft edges and paler tones beneath.**

Indenting

Drawing firmly with a smooth, blank point into thick paper can create a pattern of marks. Dry brush strokes or powdered paint will rest on the surface, revealing the indented pattern.

LEFT A pattern of marks has been indented in the paper with the side of a key and the surface lightly rubbed with pencil graphite on the finger. Oil pastel or chalk used in the same way could give a similar result.

BELOW Masking fluid has been used to reserve white areas under a wash and, when this has dried, more areas have been masked and further layers of paint applied.

Masking

For some people masking fluid is the greatest innovation, removing the need for careful painting around stamens and tiny florets and adding sparkle to a painting. For others it is an instantly recognizable painting trick and they avoid using it.

It is available as a colourless fluid or with a yellow tint, which is easier to see as the painting builds up, and it is applied by splattering with a toothbrush or painted in with a brush. However, this can be a disaster for bristles unless the brush is thoroughly and instantly washed in warm, soapy water.

When the masking fluid is dry it can be painted over. Paint settling round masked areas tends to create sharp edges, and more paint can be dropped in to heighten the sharpness of contrast. When the painting is finished the masking fluid can be removed easily with a finger or soft eraser.

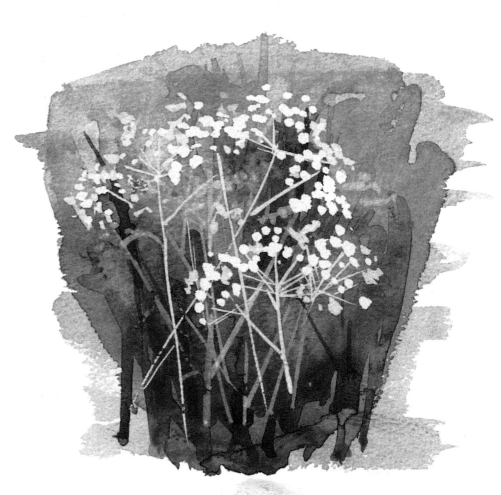

Scraping and scratching

A scalpel or sharp blade can be used to remove paint or to scrape back to the paper. In watercolour it can be used for adding sparkles, removing mistakes and creating highlights such as stems or specks of sunlight. Once paper has been scraped it cannot take any more paint.

Gouache, acrylic and oil can withstand more vigorous treatment and blades or points or sandpaper can alter the surface, remove areas of paint or even create a base for further layers.

Spattering

Speckles of paint can be sprayed onto a surface by scraping the thumb or knife across the bristles of a paint-loaded toothbrush. Masking will restrict the spattering to particular areas, and by partially damping the paper with a brush or by spraying with water, interesting textures can be created. This is an effective method of painting black poppy dust-speckled petals, and for breaking up flat areas. The Impressionists' technique of making a sparkling surface can be imitated by flicking complementary colours over each other. In acrylic and gouache, the paint's opacity allows pale colours to be speckled over darker ones.

Sponging

Paint can be sponged on or sponged off. Natural sponge produces a less regular effect. Squeezed almost dry, dipped into paint and dabbed lightly onto paper, a sponge will create its own texture. A saturated sponge will spread a wash quickly and smoothly. A dry sponge pressed onto paper will suck in paint, and leave cloud-like blanks. A sponge is an essential tool for softening edges and mopping up over-wetted areas. With skilful manipulation it can be used to pull strong paint from one area into another.

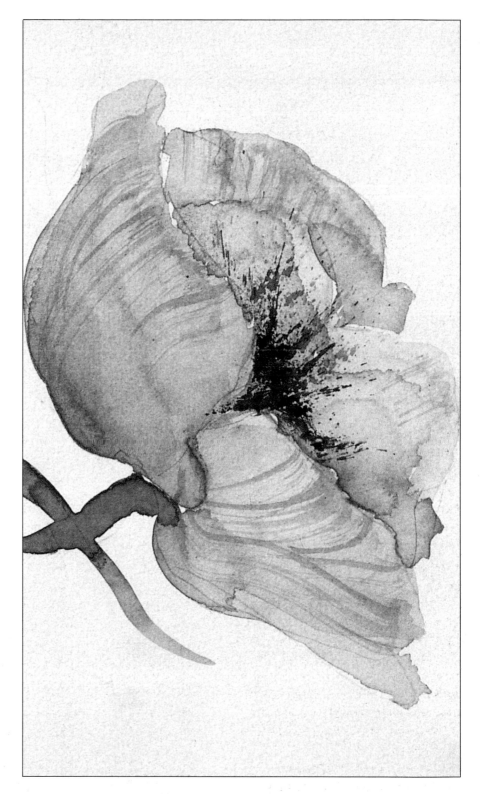

ABOVE Here hard edges have been created round the petals by blowing the paint with a hairdrier against dry areas. The ridges on the petals were made by softly stroking on paint from a dry brush. By masking certain parts, dark paint spattered from a toothbrush has been directed to the centre of the flower.

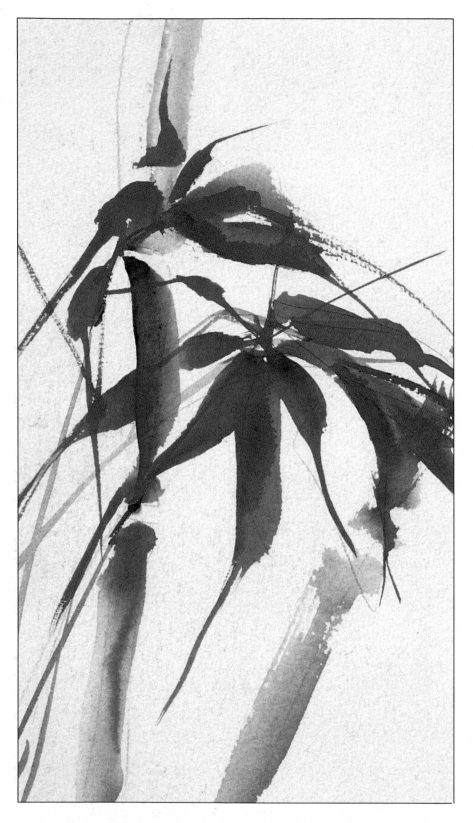

Variegated colour

Bi-coloured shapes can be made by filling the brush with one colour, drying the tip, dipping it in a strong concentration of another colour and applying the two colours to the paper simultaneously. A firmer two-colour stroke can be made by dipping each corner of the bristles of a flat brush in a different colour.

Wash

The wash is the principal technique of watercolour painting, and its luminous character is created by laying thin veils of colour on top of each other.

Wet-on-wet

Heavy or stretched paper, dampened but not soaked, is the best surface for the random and unpredictable technique of wet-on-wet. As a liberating exercise it is unsurpassed; as a component of a painting it needs to be controlled. It can establish an atmospheric background or mass of colour but requires the sharpening effect of strong brushwork to add form and substance. It is a technique that repays experimentation. The basic wash should be damp but not wet. Paint dropped or painted in will spread. As the paper dries slightly, more paint can be fed in and manipulated into the planned pattern. See the step-by-step sequence on page 60 which demonstrates the technique.

The hazy-edged result is invaluable for backgrounds and for the mass of a multifloral head, later sharpened with detail. For landscapes, gardens and multitudes of flowers, the wet-on-wet technique can describe dense areas of colour without diverting the eye from the focus.

ABOVE **A wide, flat brush with different coloured paint on each edge of the tip has been articulated to produce these two-colour bamboo leaves. On its edge the brush will produce fine lines but when pressed and turned it will splay out into flowing shapes.**

Texture and pattern

Texture and pattern can be achieved by many methods. Fabric or crushed foil, pressed into paint and lifted when dry, can form interesting textures. Spread paint on a surface, press paper into it and then peel it off. Coarse salt sprinkled onto a fairly dense wash will absorb the wet paint and leave a speckled effect. Painting over wax or oil pastels produces interesting results, and stencilling colour through open-weave fabric such as net is a speedy method of creating chequered patterning.

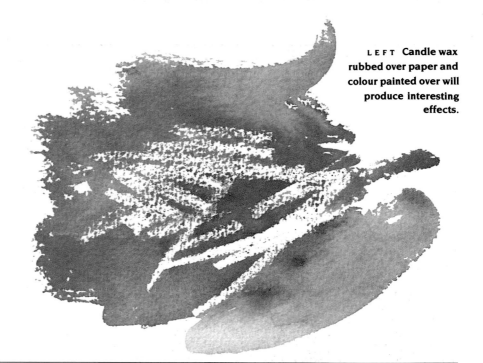

LEFT Candle wax rubbed over paper and colour painted over will produce interesting effects.

GOUACHE

Since gouache is watercolour with added body, most watercolour techniques can be used easily. The thicker consistency of gouache also lends itself to other techniques.

Additives

Gum arabic added to gouache gives it a sheen. Adding paste makes a thick, malleable paint that lends itself to interesting textures.

Gradating tone

Ribbons of colour placed close to each other and differing slightly in tone can produce a rippling rhythm.

Washing out

This method of using ink and gouache is an unusual one that lends itself well to floral images. It is best described by demonstration, so look at the following step-by-step sequence on page 32.

RIGHT Fine ribbons of gouache paint, each varying slightly in tone, have been painted next to each other to give a sense of flowing movement to these plant shapes.

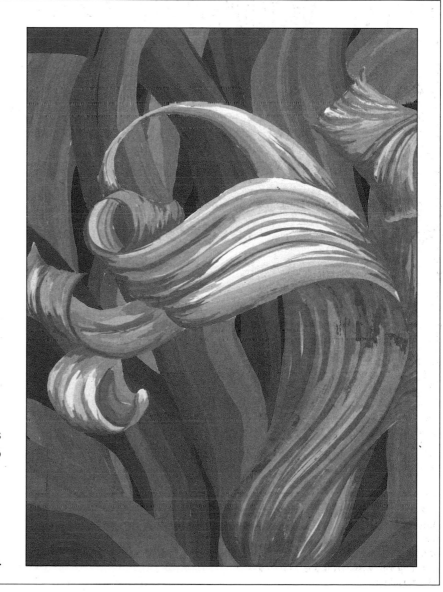

WASHING OUT TECHNIQUE FOR GOUACHE AND PERMANENT INKS

FAITH O'REILLY

This technique exploits the properties of permanent ink and gouache. The black ink intensifies the colour, and the final result looks rather like a colour lithograph or etching without recourse to expensive equipment.

1 Poinsettias are chosen as the subject for this because of their brilliance of colour and distinctive form, and they are set against a dark background. The artist concentrates on a small area of the flowers.

2 Using paper with a rough surface to absorb the colour and of sufficient strength to withstand scrubbing under a tap, the artist applies thick gouache using little or no water. The design can be drawn lightly on the paper as here, but pencil marks may show through so it is better to use unaccompanied brush strokes. Experience will give you the confidence to do this.

3 The quality of the paint is important – try to use only artists' quality or poster paint in pots and look for permanence marks. This is because the colour will bleach out as the ink washes off. Any areas left without paint will be black in the final image. White gouache can be used in any areas that are to remain white. At this stage greens have been added to the background behind the red flowers.

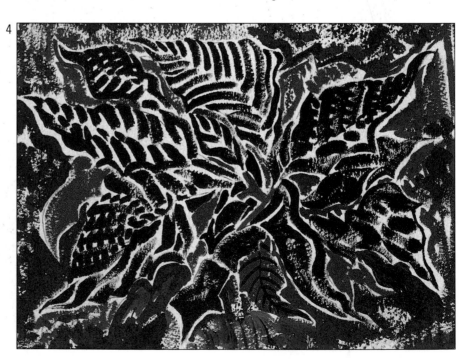

4 When all the colours have been applied, make sure that all areas you do not want to be black are covered in coloured or white gouache.

5 After allowing the paint to dry, preferably overnight, apply black Indian ink over the whole surface – other dark-coloured inks can be used as long as they are permanent. The ink is applied quickly using a large brush so that the underlying paint is not disturbed too much.

6 The work is left to dry for half an hour. Then it is gently washed under a tap until the ink begins to lift off. A shower can be used to give more control to the lift-off process. Various results will ensue, and a nailbrush or washing-up pad can be used with a light scrubbing action to make textured marks on the image.

7 The wet paper is then stretched on a flat board, stuck down with gummed paper and cut off the board when dry.

ACRYLIC

The substance of acrylic is more akin to watercolour and gouache, and many of the techniques already mentioned can be used. By diluting the paint with water or acrylic medium it can be manipulated in similar ways. Acrylic paint dries rapidly to an insoluble film, and this speed of drying is one of its principal assets.

Glazing

Acrylic paint is ideally suited to glazing. Because it dries rapidly, thin washes of colour can be laid over each other in rapid succession, producing a subtle translucency. It is particularly effective in the initial stages of a painting, and a combination of glazes and thicker opaque areas will produce a lively surface with depth and body.

Hard edges

Because of its body and speed of drying, acrylic paint makes crisp edges, either butting up against other colour, or by using tape or paper mask. It is ideal for fine lines such as stamens, hairs, feathery leaves or thin stems.

OIL

Oil paint is a most versatile, easily manipulated and long-lasting medium. There are two basic methods of applying paint.

Alla prima is a simple and direct method of applying paint, in which the work is usually completed in a single session, using the spontaneous application of thick colour, generally on a white ground, without later manipulation. This was the technique that was used by the Impressionists, who painted mainly out of doors, often in full sunlight, using pure colour on a white ground.

The second method is the "traditional" one – the more carefully conceived method by which layers or strokes of paint are built up slowly, "lean to fat" – starting with very thin layers of paint and gradually applying it more thickly, either adding more oil or using paint straight from the tube.

Oil painting techniques include the following.

ABOVE A palette knife is an effective means of applying paint thickly, speedily and smoothly, and a useful complement to brush painting. Here both methods are combined to create a lively, richly textured picture by Shirley May.

OPPOSITE This detail of a large composition shows alla prima painting – the method beloved of the Impressionists – which is the spontaneous application of thick colour over a white ground without later manipulation. It is a fast, vigorous and fresh method of working.

Frottage

Non-absorbent paper, either smooth or crumpled, pressed into the surface of the paint will leave a rich, patterned texture.

Glazing

This is the technique used by the Old Masters. Paint with little body colour, thinly applied in several layers, builds up a subtle variation of colour and a rich sheen. This gives a luminous quality to the surface because light is reflected out of the painting from the opaque pigment below the glaze.

Oil bars

Oil paint is now available as thick or thin sticks. They can be dipped in white spirit or turpentine and used for drawing, or used in conjunction with conventional paint.

Scumbling

A layer of opaque paint is laid over a layer of dry paint of another colour or tone, in such a way that some of the lower layer shows through. The paint can be applied with brush, rag, palette knife, crumpled paper or any method that ensures that the paint is uneven.

LOOKING AT PLANT FORM

There is a rhythm and pattern in the natural world, and discovering this can make drawing a complicated form surprisingly easy. The study of this pattern and rhythm has occupied many artists, and the adaptation of these elements has formed the basis of innumerable designs. Classical Greek architecture is richly embellished with acanthus leaves; the fan-shaped lotus was both a prolific design source for the Ancient Egyptians and a symbol of eternal life; and the entire Art Nouveau movement – its architecture, painting, furniture and jewellery – is rooted in the sinuous lines of flower and leaf.

Let us start by analysing plants with the scrutinizing eye of a botanist. If you look at the way a plant holds itself, the manner in which it stands, climbs or spreads, a personality will be revealed, vigorous and erect, soft and inclining, undulating and invasive. This manner of growth will give you the skeleton. Closer analysis will unravel the structure of the components – the composition of the flower head, the shape and texture of petals, the way the leaves join the stem, the roots and fruits – and the way they all fit together. A picture will emerge from this investigation of a singular identity with pronounced characteristics.

There is another equally important way of looking at plants. It is the exploration of what you actually see before you, the jigsaw of shapes made by plants facing you at odd angles with petals overlapping and leaves and stems twisting, bending and crossing. You will see colours and patterns made by shadows, and by leaves set against the light. Analysing the plant in this way will reveal a group of shapes, some of which bear no resemblance to the conventional flower shape you think you know, but which are the reality of what you actually see.

LOOKING AT THE WHOLE PLANT

Life force nudges the plant from the ground and causes it to grow upwards, extend into the air and spread itself to light and sunshine. This channel of energy, the spinal cord of the plant, develops in a manner that suits the plant's particular needs – sometimes vigorously thrusting and spreading, sometimes winding or bending. This continuous line of growth extends right to the flower heads and branches out to the tips of the leaves. The character of the plant lies in this line and to follow it in a logical way helps construct what you are painting. When drawing the plant it also helps to draw from root to tip rather than the other way round.

It is a good exercise to analyse in a few lines the basic skeleton or to see the plant in silhouette. Think of particular gestures – the feathery haze of gypsophila flowers formed by continuous branching and dividing from the main stem, the sentinel stem and bursting blooms of the amaryllis, the fan of an iris rising from a sheaf of sword-like leaves, a cactus flower resting like an unexpected butterfly on a prickly dome. Some plants cling or crawl, and the stem winds at extraordinary angles to reach support. The characters of some plants depend on their mass – a network of grasses, or a clump of rock flowers – and if this is missing when you draw the plants, no amount of meticulous detail will compensate. So it is important to think carefully about this characteristic identity.

BELOW Many designs have their origin in plant form. The Ancient Greeks used the acanthus as a source of decoration. Carvings like this are found throughout Greek architecture.

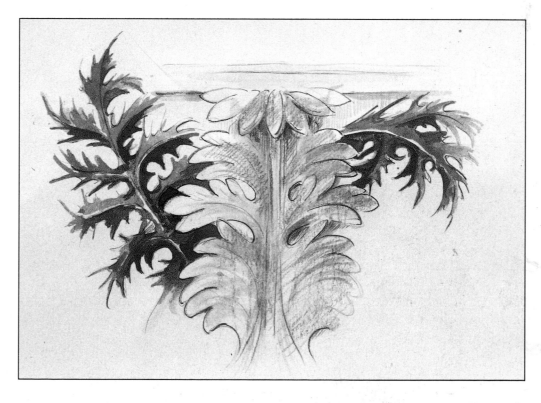

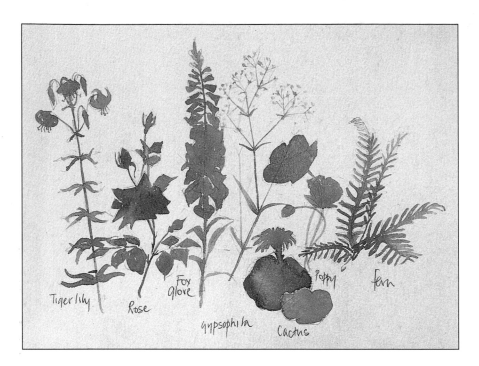

Tiger lily

Rose

Fox glove

gypsophila

Cactus

Poppy

fern

At various times in the life of plants the growth pattern alters and the structure changes – buds break out, exploratory tendrils lead the plant in a different direction and flowers erupt into bloom. Later in its life the energy wanes and causes petals to shred at the edges and vivid colours to fade; seed pods appear, and the plant bends, sags and fragments. These different aspects of the plant's life are just as interesting as the flower in full bloom, and incorporating these in a flower painting will add an extra dimension.

The identity of a plant also lies in its rhythm, the repetition of shape and line. A profusion of tiny daisies has a rhythm in the massed repetition of shape, and the winding stems of some plants, although each has its own distinctive curve, create a repetitious pattern of movement which is a distinguishing feature.

ABOVE The shape and structure of some plants is so distinctive that they are instantly recognizable even without the clues of colour and detail. A silhouette highlights the features that give rise to this recognition.

BELOW Behind these silhouettes an intense background throws into relief the three groups of plants by Christine Holmes, emphasizing the tilt of each flower head and the different qualities of the leaves. The papery flower bulb and twine support are as much part of the identity of a potted hyacinth as the blooms themselves.

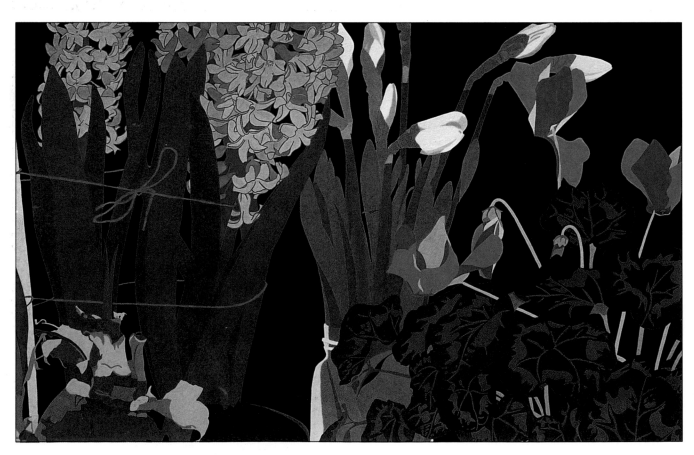

LILIES, TULIPS AND GRASSES

E L I S A B E T H H A R D E N

Combining contrasting shapes, colour and textures can make a simple group more interesting. In this watercolour exercise a few flowers, chosen for their differences are combined. The palette on this occasion is Naples yellow, yellow ochre, raw sienna, cadmium yellow, sap green, cadmium orange, cadmium red, Hooker's green, raw umber and viridian.

1 The flowers are arranged to display the different shapes of the plant to best advantage, using the orange flowers as the focus and the darker leaves to give diagonal balance. The lighter and more delicate flowers are arranged to give a freer feel to a fairly conventional composition.

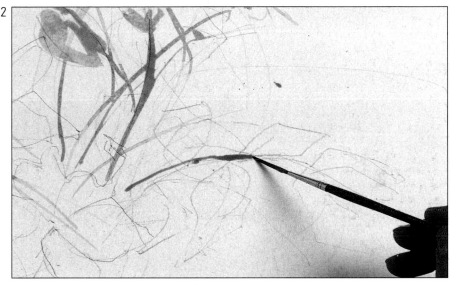

2 A rough drawing is made to establish tones and general rhythms in the composition and this is copied lightly to the working surface – in this case stretched, mediumweight watercolour paper with a NOT surface. The main rhythm of the piece is painted in with very dilute green paint. These lines will either stay as stems or parts of stems, or will disappear under darker paint.

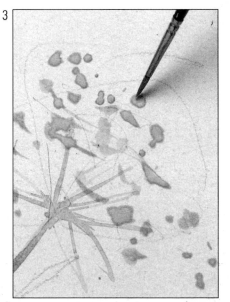

3 The feathery flowers of the cow parsley and flower stamens are blocked out with masking fluid. This allows fast and fluid washes to be used with freedom, and avoids having to paint laboriously around very detailed areas.

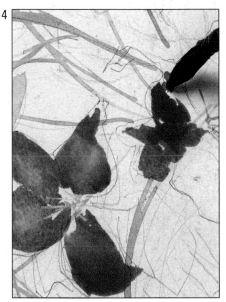

4 The shape of the lilies is blocked in with a light cadmium orange wash.

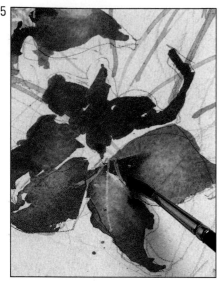
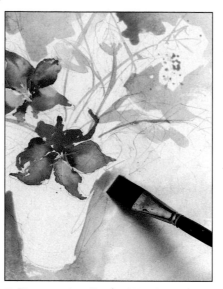
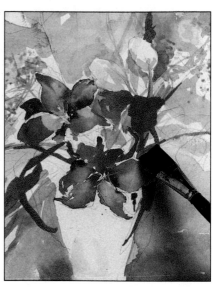

5 A darker cadmium red is dropped into the drying base wash. This building up of colour begins to give form to the petals and definition to the masked-out stamens.

6 The group is still a muddle of shapes and lines, so the artist applies a light wash of Naples yellow round the flowers and vase, and drops a darker ochre in as it dries. Now the form of the whole can be seen and the shape built up.

7 Light sap green with a touch of yellow is used for the paler leaves. Much of the work is done with a flat brush, which is twisted and turned to form the strong shapes of the tulip leaves.

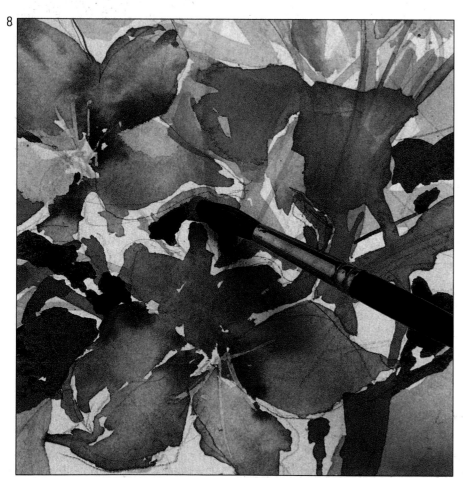
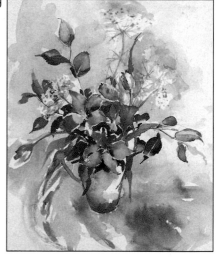

8 A darker green is introduced. This throws the red lilies into relief and defines their shape and colour. It also adds weight to the lower half of the group.

9 Taking an overall view it becomes clear that various areas need weight and definition. The vase is given more substance – white patches are left where the light falls and the reflected colour of the drapery adds weight to the shadows. The tulips are painted wet-on-wet, adding touches of red where the petal tips emerge from the bud, and emphasizing the line of the stems, which leads the eye to the left of the composition.

10 The focus of the group is the lilies. A stronger and darker red picks out the areas of more intense colour and shadow to build up their shape.

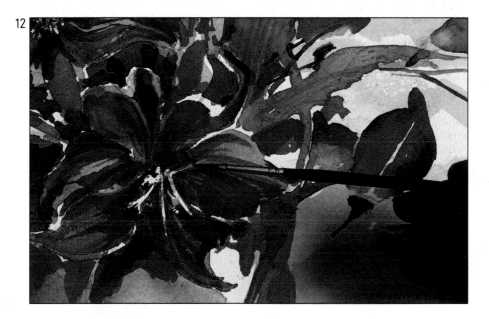

11 The shadow under the vase gives a weight to the whole, and the artist is in a position to make a considered assessment of the composition. The masking fluid is removed and details painted on the cow parsley with a fine rigger brush. The same type of brush adds the thin grasses and pattern on the tulip leaves.

12 The lilies need more colour, some indication of the ridges on the petals and a sharp definition of the distinctive stamens.

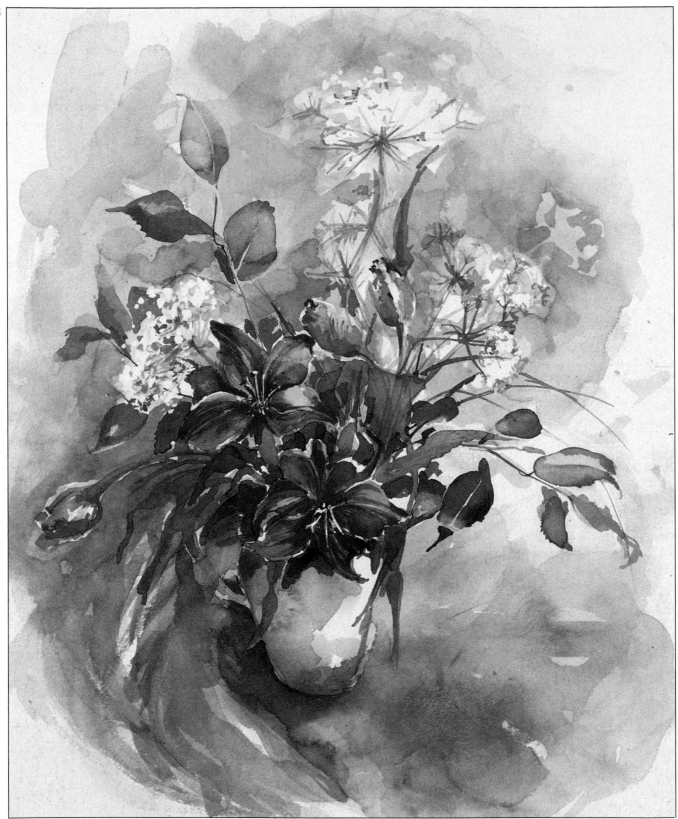

13 Critical assessment is a valuable learning process. The rhythm of the piece works well, but possible further improvements would be to give the central area more depth of tone and to anchor the vase of flowers more firmly by increasing the substance and definition of the background.

LOOKING MORE CLOSELY AT PLANTS

It is very easy to look at a plant and see it in terms of flowers and leaves, to draw the most distinct features and then haphazardly join them. The structure of a plant is in some ways like that of the human skeleton, so it makes much more sense to draw the plant's basic skeleton along what might be called its spinal cord, and move outwards via the all-important joints and angles towards the flowers and leaves. Head, hands and fingers move in all manner of ways, but they are dependent upon the extension of the joints – shoulders and hips – and they have little identity when drawn unless this join is convincing. The equivalent of head, hands and fingers are petals and leaves; the hips and shoulders are the junctions.

Junctions

One of the key areas in a plant is the junction. Branches, flowers and leaves and stem are joined to each other in distinctive ways, and these junctions hold the key to the structure and posture of the plant.

Sometimes this attachment is simple, leaf stalks springing from a simple bump. Sometimes the junction is a complicated knot of twisting foliage.

Points to notice when constructing junctions are how the collection of leaves and stems fit together, what goes over what, the angle of the join and whether the leaves or flowers spring from the stem or unwind from a wrapping. All this will alter at various stages in the life cycle. The colour at a junction may be different from the rest of the plant, and the texture and width of the stem may vary above and below this point.

BELOW LEFT Cow parsley has the most complex junctions, both ridged and bulbous, and the feathery leaves spring out in all directions. This detail is part of a larger drawing in which the shape of background plants was made by using leaves themselves as a mask for spraying.

BELOW RIGHT This detail is part of a larger composition by Rosemary Jeanneret (see page 65). One of the features of stems is that they are often seen bunched together, crossing and twining, losing their singular identity, but forming a distinctive mesh.

Notice also the junction at the base of the plant, the way the plant grows from the root – as a single column or as a mass of stems – and the way the flower is attached to the stem. Once you are familiar with the junction, the rest will follow easily.

Stems

When looking at the junctions keep an eye open for different types of stem – angular, sinuous, woody – and the marks on them – leaf scars, speckles, peeling tissue, thorns. Look at the texture – fleshy, flaky, hairy, smooth – and the colour, which in many cases may be totally different from the leaves and stem. Look also at the way light defines a stem, and how the gradation from pale to dark can emphasize the roundness or squareness of the stem, and how the repetition of dark and light shadows on the curves creates movement as they thicken and taper. The stem is a very useful element in a loose flower painting; colour dropped into wet paper, creating hazy shapes can be given a structure by simply painting in a few stems.

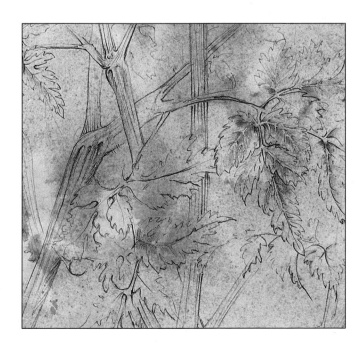

Leaves

The basic shape of the leaf may vary enormously. The important point to look for in a leaf is the central spine. The leaf growing along this spine may be a simple oval shape or more complex and divided into fingers. The edges may be smooth or frilly, serrated or prickly; the texture may be hairy or shiny and glossy.

Many leaves are complex, with leaflets placed on either side of a central stem. Look at the way these are arranged, opposite each other or alternating, and the way they join the central stem. Look at the angle at which leaves grow, unwinding from a central stem, like the iris, stabbing upwards like a sword or

ABOVE Using watercolour to investigate a plant takes advantage of the medium's particular behaviour. Dark paint leaching into the paler leaves expresses the crispness and rustiness of dying leaves in this study by Jane Dwight better than any amount of laboured drawing.

inclining with age. Establish the line of growth and the rest will follow.

Leaf veining is often responsible for the pattern on the surface. Even a small area of veining can identify the whole. Notice the texture of the leaf surface and its underside – bristly, waxy, hairy – and the colouring, which may vary in different parts of the leaf. Young leaves are frequently pale; stalks and leaf edges are often a different colour. Variety of leaf shape can add pattern to a painting.

BELOW A group of ivy leaves collected to examine the considerable variety of colour in one genus of plant. The veins are an important part of the pattern of this plant and help define the line of growth.

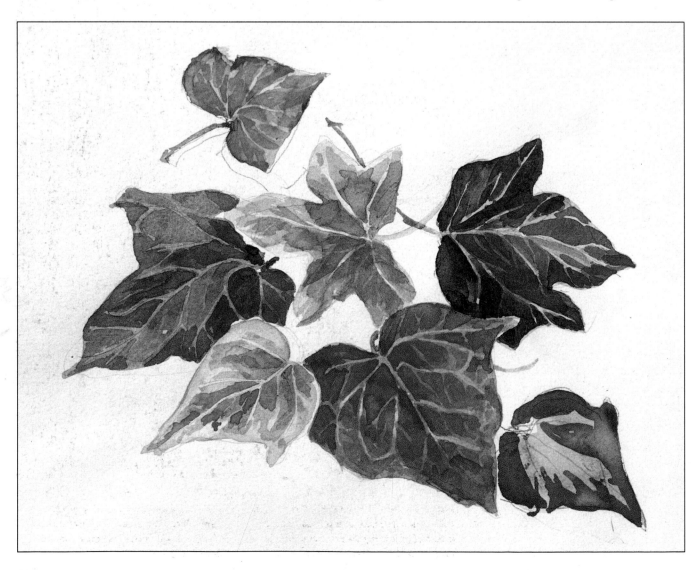

Flowers

There are thousands of different categories of flower for the botanist, but the flower painter need only become familiar with several basic shapes. The majority of flowers have regular petals radiating from a centre. The petals may be limited to a few, like the magnolia, or there may be many, as in the daisy. Knowing that the plant is composed of, say five petals, makes drawing a great deal easier.

Some radiating plants are more complex and have a mass of tubular florets surrounding a central dome, itself composed of tiny florets. The daisy and the sunflower are examples of this arrangement of petal. The petals of chrysanthemums and roses spiral from a tight centre, becoming larger and paler towards the edge. In the sunflower, the central dome has a distinct pattern, a spiral of dark shapes that change radically through the life cycle, ending as a huge cluster of seeds.

Another shape of flower is the bell. Tubular flowers radiate or incline from a central point, or hang at various points down a stem. The foxglove comes into this group of flowers. Look at the way the flower heads are arranged, the way they face and the pattern at their edge. Sometimes they are exotically frilled, sometimes the edge is a different colour from the flower itself. Look inside a bell-shaped flower where the patterning is designed to attract insects to the pollen, and you will find dots, speckles and sometimes intense depths of colour.

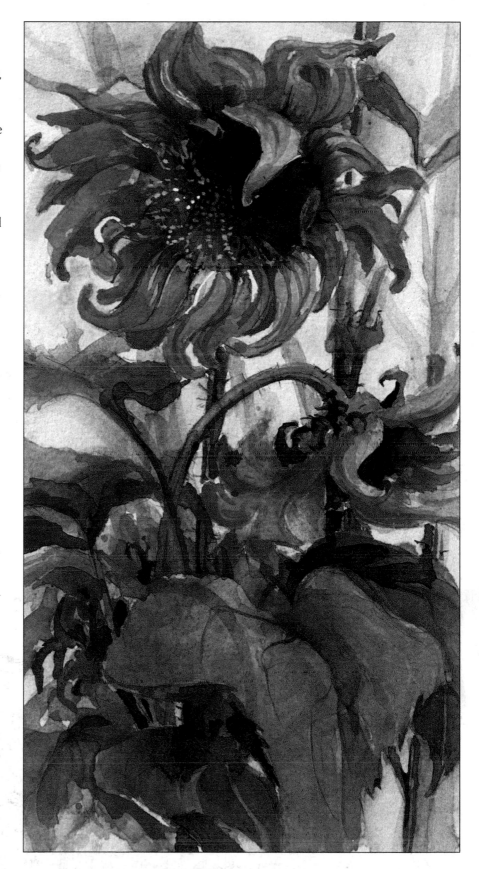

ABOVE **The sunflower is a radiating plant both in name and nature. It is composed of a halo of yellow ray florets surrounding a large pad of disc florets which grow in a spiralling manner. The sunflower is particularly interesting at all stages of its life cycle and is one of the most dramatic flowers to paint.**

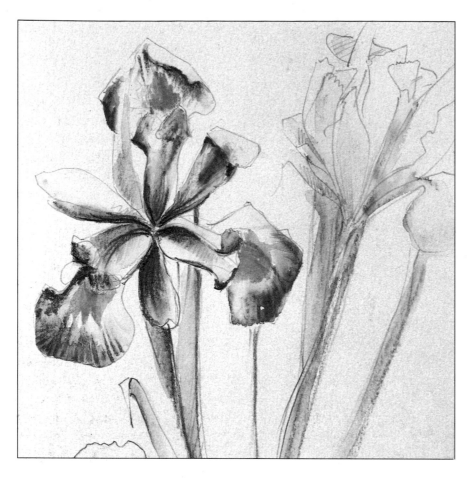

Apparently complex flowers like
the orchid and iris also have distinct
structures. The pattern of an iris is
basically a "Y" with another "Y"
crossing it. What looks like a
haphazard jumble of different
shapes can turn out to have an
identifiable pattern.

Patterning itself can be a
distinctive feature of a flower.
Snake's head fritillaries have a
chequerboard on their petals. Some
flowers develop patterns to mimic
the qualities of insects. Dried
seedheads have recognizable
patterns, and berries and fruit add
spherical shapes to a group.

Skilled manipulation of paint can
play a real part in capturing the
texture and ephemeral quality of
petals. For watercolour painters,
water dropped into paint can make
frilled petal edges, and enable
shading from an intensely coloured
flower centre to its pale tip. Two
colours on a brush delineate a
multicoloured petal in a stroke.
Paint on a dry brush can be used to
draw thin grasses and the lines and
veins on leaves and petals. Dryish
oil paint and acrylic brushed lightly
over a surface can create ephemeral
flakes of petal. Thick impasto paint
can mould leaves and petals, buds
and berries. Spatter creates pollen
and speckled markings, or a haze of
tiny blooms.

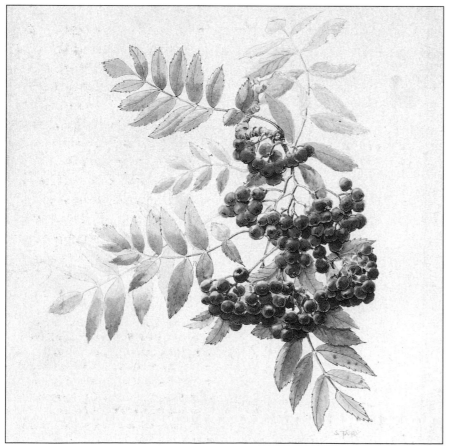

LEFT Round berries add a further
dimension to the repertoire of the flower
painter. Sue Merrikin is a botanical artist
whose detailed study of rowan berries is
not only an accurate representation of
form, but a pleasing composition of
complementary colours.

HOW THE PLANT PRESENTS ITSELF TO YOU

This close analysis of plants identifies their components and how they are arranged. How flowers present themselves to us and how we see them are two different matters altogether. If we look at the human hand spread flat, the structure is five fingers joined to a palm and so on. But looking at this same hand, say, holding a paintbrush it becomes a different shape completely; no fingers are visible and the silhouette becomes an elliptical rectangle. The same theory applies to flowers.

Flowers can be simplified into basic shapes – circles, stars or bells. These shapes are dramatically altered by perspective. A circle seen at an angle becomes an ellipse. A group of daisies will contain a variety of forms depending whether the flowers are facing you, some full head and circular, or whether they face upwards and appear as an ellipse, presenting larger petals towards you with only the hint of petals on the other side of an oval dome. A flower seen from the back will reveal the joining of the stem and the calyx set against the underside of the petals.

The general inclination of leaves is to face upwards towards the source of light. This means we sometimes see them as a thin line, or an undulating thread. A curving leaf will reveal part of the underside is often different in colour and texture from the upper surface.

Plants seen against each other create patterns of light and colour. To give identity to this jigsaw, find the dominant element and set other things against it. Look at this main element, perhaps a large leaf or flower head. Notice how its shadow falls on the leaves behind, how stems cross in between, and how small patches of light appear in the spaces. Notice how the colours behind may be weaker in tone and intensity.

Observation and an understanding of the make-up of plants should be used as a back-up to the emotional response that must be at the heart of a picture. This knowledge will give a sense of familiarity with the flowers you intend to paint and, thus, a confidence in capturing the particular qualities that inspire you to paint them. Matisse's paintings of dancers, for example, capture the essence of rhythmic movement, but behind this perfect spareness of line and shape lies a vast storehouse of observation, study and knowledge.

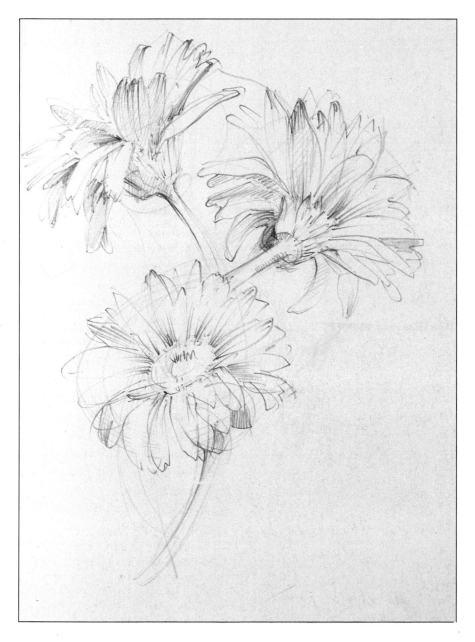

LEFT When a round daisy head faces away from you it will appear as a different shape, the circular form altered by perspective to an ellipse. One very helpful technique for drawing flowers is to draw these basic ellipses, in this case the central dome and the shape of the flower surrounding it. The petals will then radiate from one to the other.

A BOWL OF ICELANDIC POPPIES

R O S E M A R Y J E A N N E R E T

The papery petals and wanton growth of Icelandic poppies have a particular
appeal for an artist. They seem to encapsulate the very essence of life and
movement, and their texture and subtle colouring reward detailed examination.
This group was chosen to illustrate the disposition and character of the plants,
and was painted and drawn with watercolour and gouache and watercolour pencils.

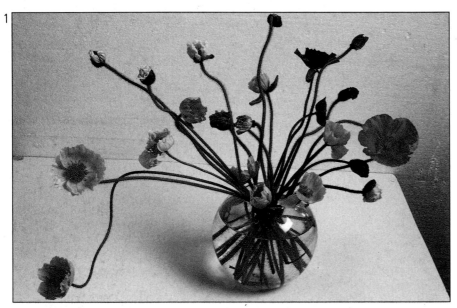

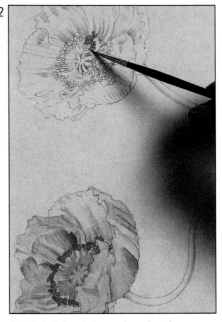

1 The poppies are arranged in a glass
vase to echo the splay of branching stems,
and the arrangement is set against a white
background to show off the delicacy of the
flowers.

2 A brief sketch is used to plan the
general pattern on the paper. The artist
then lightly draws the first flower with a
fine, hard pencil on Fabriano Artistico
paper. Thin washes are painted to build up
the delicate tones. While the first flower is
drying, the artist starts work on the second
flower and, moving from one to the other,
builds up with pencil, crayon and wash.
The intense concentration on these two
flowers is part of this painter's way of
working. She builds up a familiarity with
the shape and identity, and finds that this
establishes a rhythm for the whole
composition and that other flowers will
then slot easily into place.

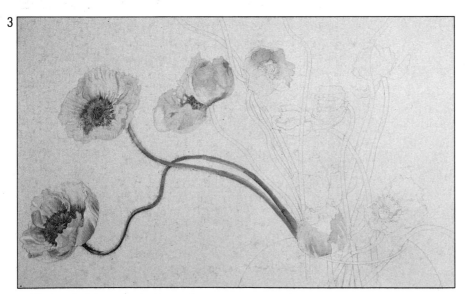

3 The bend of the stems is extraordinary
and distinctive. Using thin paint and a
medium sable brush she follows their lines
back to the vase and then starts to fill in
the other plants in relation to these. The
whole structure is now sketched in.

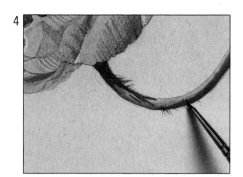

4 Fine brush work and crayoning picks out the shadow and texture of this stem. The work seems painstaking but the artist works with a fluid rhythm and knows exactly what is needed where.

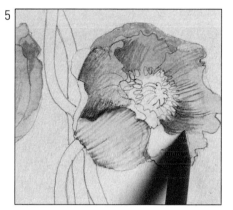

5 Moving backwards and forwards the flowers are blocked in and built up, the artist paying particular attention to the angle of the head and subtlety of colour. Here you can see the fine texture of the petals being put in with a watercolour pencil.

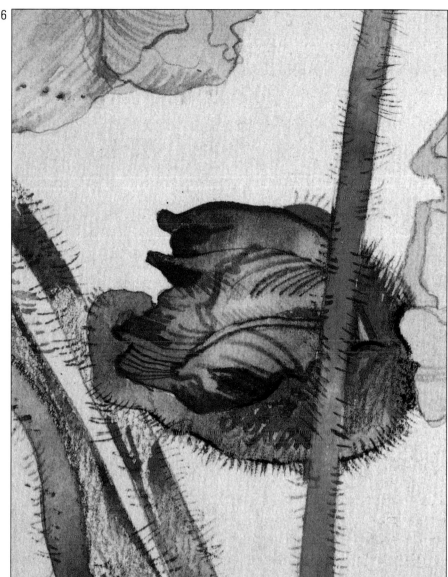

6 Watersoluble crayon is used to draw the shape of this particularly lovely unfolding bud. Water applied to some areas creates controlled areas of intense colour.

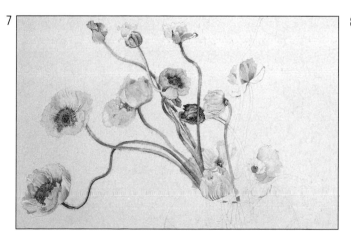

7 The whole composition depends very much on the careful interlacing of stems. When a group of flowers has been completed the background stems are woven into the overall pattern.

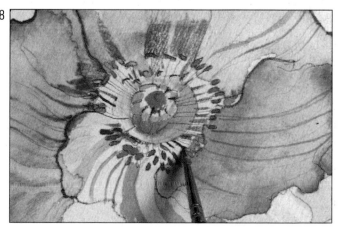

8 A fine brush picks out detail in the centre of a flower.

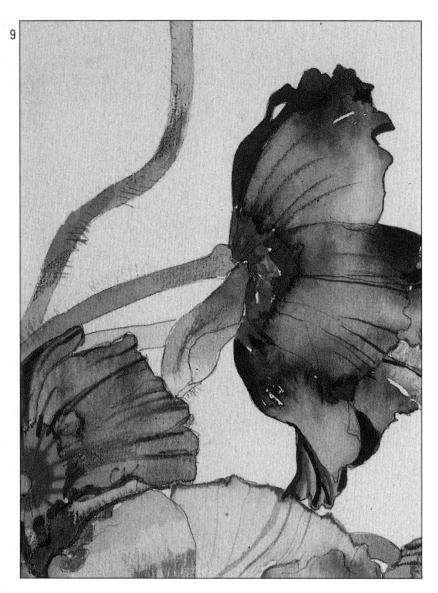

9 Here, the artist is paying particular
attention to the join of stem to flower.

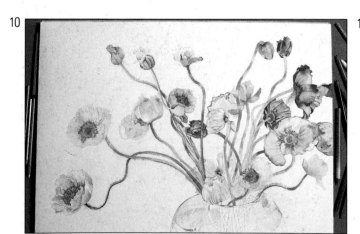

10 The painting of the flowers is
completed, but the vase needs to be
worked on.

11 Painting glass needs intense
concentration. An underlying wash
sketches in the delicate patches of
shadow, and crayoning sharpens the tone
and defines edges.

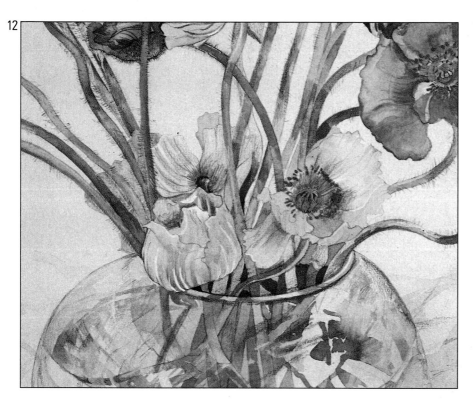

12 The shape of the stems in the vase echoes the spread above, but reflection and deflection create their own abstract pattern, a mesh of unexpected shapes and colours.

13 The painter takes a careful look at the whole and makes adjustments. Some stems are strengthened, and more intense areas of colour built up round the neck of the vase. A web of shadow painted in watercolour echoes the flower shapes and unifies the whole.

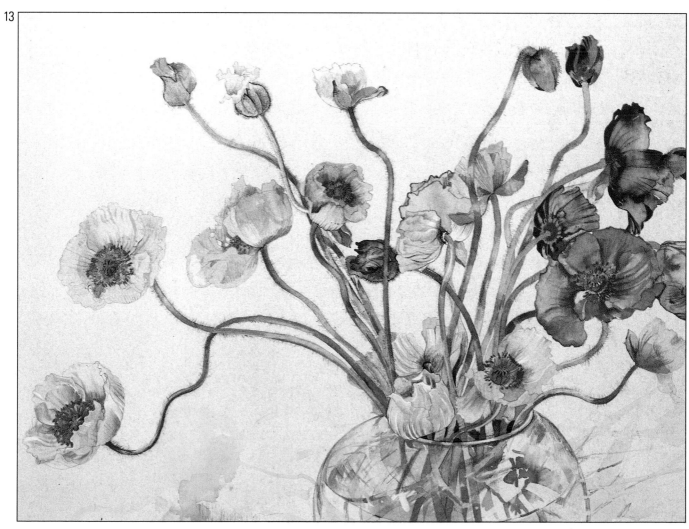

5
SKETCHING AND DEVELOPING A SKETCH

For the flower painter, sketching can serve many purposes. It is essentially a direct rather than contrived response and, as such, has spontaneity, freedom and vigour in its favour. No preparation is needed, so there is none of the nervous apprehension that sometimes accompanies the first brush stroke of a painting. What happens on the paper matters not one jot and can be developed, discarded or just enjoyed.

SKETCHING AS AN INSTANT RECORD

Sketching can be an immediate recording of a visual image that appeals and is fundamentally a very personal impression. What may appear as a jumble of lines that are unintelligible to others is crystal clear to the artist as the essentials of a plant or the key structure of a group, sufficient to call it to mind at a future date. As well as recording physical images, a sketchbook can be a means of recording aide-memoires and thought processes, which can be explored and developed without their being subjected to the criticism of others.

Ideas are fickle and elusive phenomena. They make unannounced appearances, rarely when faced with a pristine sheet of stretched paper or canvas and a ready brush, but often at particularly inappropriate moments when germs of ideas scudding around in the mind clarify. Having the means of sketching instantly accessible, even

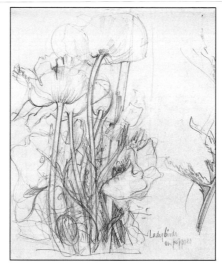

ABOVE This sketch became the basis of a print. Oriental poppies have a wonderful inclination of stem and looseness of flower head, and the two characteristics make a lively combination. The drawing has vigour and excitement, and the artist wove a mesh of flowing lines to find the rhythm of each stem.

BELOW This series of thumbnail sketches by Lynne Moore explores flower composition in terms of brilliant colour. She will later use these as a basis for large prints. By working in small scale she can see how the colours and shapes balance each other.

if it is only a scrap of paper and a felt-tip pen, allows you there and then to jot down the idea or the essentials of a visual image that might otherwise be lost.

The limitation of time can add excitement – a five-minute sketch with a ballpoint pen can have tremendous energy and impact. Sketching will develop as a visual shorthand that is useful when extracting the essentials of an image in the time available, translating the quintessence into swift strokes, outlines and pattern. There may be an opportunity to fill in the details, either at the time or by returning at a later date, but the main structure and perhaps the colour and texture of this image will be on record.

So a sketchbook at the ready can become an essential item and develop into the most precious of possessions. It will be of full of clues that instantly conjure up a scene or moment in time, and these can prove far more potent than a photograph because in sketching

ABOVE **This five-minute sketch in pencil and watersoluble crayon tries to catch the thrust and strength of a spray of shaggy chrysanthemums.**

the image the eye has travelled over each line and shape and imprinted them on the mind. You may choose to use the sketchbook to build up a storage system of material that might be relevant to a proposed painting – references such as cuttings from catalogues, detailed sketches, notes of colours, pressed flowers or leaves, rapid scribbles of an interesting leaf pattern or distinctive markings, and names of flowers. All this will be on hand as a source of stimulus and a visual banking system that will pay high dividends.

SKETCHING FOR FAMILIARITY

Sketching can be used to get to know a subject, to build up a familiarity prior to painting and to see it in new ways. Try thinking laterally and approaching the subject from a distance and close up, as if with a wide angle or a zoom lens. Are you are looking for a broad view and a general impression or for details? It will affect the way you look. Think of the image in terms of shape and colour and tone, the gradation from dark to light.

Detailed sketching is an exploration that offers the thrill of meeting something new and of not knowing what you are going to find. Starting to investigate the flower

head of a geranium, for example, the eye might become attracted to the knotted joints, or a pair of overlapping leaves farther down the stem whose shape is exciting. Sketching allows you to move where you will and brings a confident familiarity. Looking carefully at the geranium and allowing the eye to travel will ensure that you are well acquainted with the flower and are familiar with its five-petalled bursts of florets and its scalloped leaves. When you set about painting it, the brush will flow more freely.

BELOW **After making a fairly detailed study of this geranium, the artist decided to paint it in colour to pick up the touches of red throughout.**

SKETCHING TO DEVELOP TECHNICAL DEXTERITY

Drawing and painting can often be hampered by the necessity of producing finished work, paintings that will work well, accurately recording a new image, and perhaps producing something that will stand up to the comments of others. All these requirements place inhibitions upon the artist and stifle and tighten freedom of expression.

Sketching is free of these constraints, and offers a chance to be loose and unrestrained, to explore at will and to exercise the hand and eye, thus developing technical dexterity.

Draw freely, regardless of the result. Try making fast impressions of a flower group in different media knowing that you will discard them – you can always change your mind if something remarkable emerges. Tape a stick of charcoal to the end of a long stick and sketch on the floor or on an easel, smudge the result into a tonal study, strengthening the dark areas and rubbing out the light.

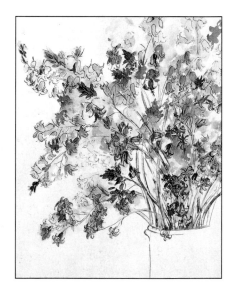

ABOVE **This sketch in ink and wash tries to capture the rhythm of a mass of bluebells. The artist placed the container to the side of the composition to emphasize the flow of the stems.**

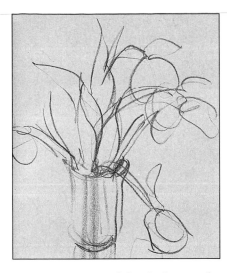

ABOVE A ten-second sketch of a vase of tulips, drawn without taking the eye off the subject – an exercise which develops hand and eye coordination and can lead to unexpected results.

Try also drawing in charcoal or crayon without letting your hand leave the paper, and without taking your eye off the subject, not even for a fractional glance. This serves to concentrate the entire attention upon the subject, following the contours and angles without breaking the attention to look at what is happening on the page. The results may surprise you, the maze of lines will reveal unexpected shapes of great vigour. Assess what is there and see if you can develop it.

Be messy with paint – spread it freely with your fingers or rags; squirt it straight from the tube and mix it around with water or sticks;

drop colour onto wet paper or onto a glass surface and take a print by pressing a sheet of paper onto this paint. The possibilities are endless and will help to overcome the terror of the blank page and fear of failure. Vary the size, texture and colour of paper or painting surface. One antidote to staleness is to paint the same subject in different media.

BELOW Texture can be created by the most mundane of materials. Here, strong paper is folded and the edge dipped into thick gouache paint and used to form the sword-like shape of an iris. Shorter pieces of stiff paper manipulate paint into the radiating form of the flower.

DEVELOPING FLUIDITY OF LINE

Freedom of expression will add to the vitality you capture from the plant. In most plant forms there is a definitive flow in the shape of leaves and petals and the curve of stems. The curve in particular can be notoriously difficult to draw, yet this is a very important element in flower painting and is also seen in the ellipses of flowers and the rounded lips of containers. Stems are perhaps the most tricky of all, however. Some have pronounced bends, others gentle curves. Some are perfectly straight for the most part, then erupt into a shape. The direction of growth is often quite different from the way your arm naturally moves, and the effect of light means that they are dark and thick in some parts and light in others. Swing your arm like a windmill and let the curves flow.

There is an inclination to make branches join at exactly the same angle, to paint leaves all the same size. There is enormous variation even among the leaves from a single plant. Mix up some colour and paint different sized leaves splaying at different angles, varying the colour and strength. Do not be afraid of the paper. If your sketch does not work, try again.

BELOW Janet White has employed two techniques here to create a mesh of bamboo foliage. The basic image is drawn lightly and the leaf shapes left by painting a blue background around them, making a negative space. A twig dipped in household bleach adds a further web of lines, which leach the colour and form finer details.

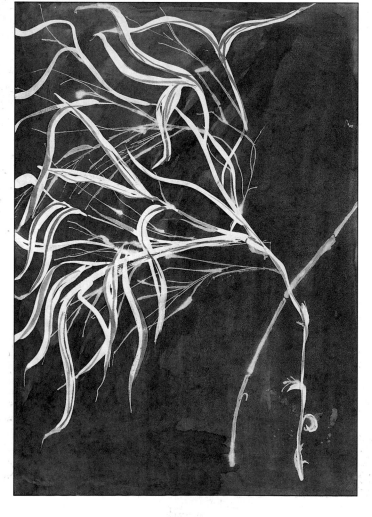

SKETCHING AS A LEARNING PROCESS

One tried and tested method of learning and developing skills is to study the work of other artists whose works you admire. Copying allows you to register a painting in your mind, to analyse the rhythm and pattern of the whole and perhaps to discover an underlying pattern, unseen at first glance. It enables you to see how the painter has handled colour and overcome problems that are inherent in any subject.

Sketching at an exhibition or gallery can be a permanent record of particular favourites; copying from reproductions is an adequate second best, allowing you more time and a greater selection of materials. Copying a reproduction and then searching out the original can be an enlightening and invigorating experience.

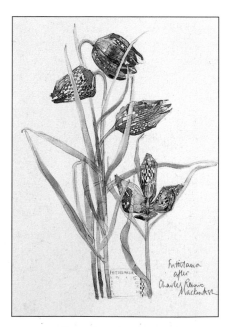

ABOVE The artist was so inspired by an exhibition of the work of Charles Rennie Mackintosh that she copied a plate in the catalogue. What had particularly appealed was the strong sense of pattern both in the flower heads and in the arrangement of the whole group. Mackintosh used plant forms as a basis for his remarkably individual style of architectural decoration.

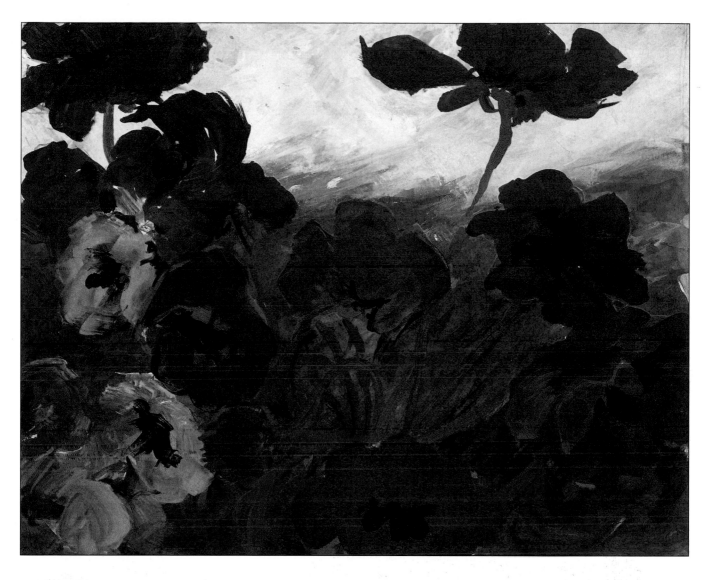

ABOVE Emil Nolde made gardens wherever he settled. His paintings combine the love of flowers with the energy and brilliancy of the German Impressionists. The artist made this copy from a small reproduction of Nolde's to imprint a favourite image in her mind.

LEFT Preliminary sketches help to assess whether a composition will work. The compositional lines formed by the dresser would normally pull the eye out of the picture, but the dark shades and tonal contrast of the flower group hold the attention.

MATERIALS FOR SKETCHING

Arm yourself with a variety of materials, and enough paper to allow for plenty of discarding and big enough to work large. For sketching outdoors equip yourself with a drawing surface small enough to fit in a pocket or bag and sturdy enough to withstand water and time – a well-bound sketchbook will keep your collected jottings together for years whatever media you use.

ABOVE, LEFT AND OPPOSITE A florist's shop can be the most magical source of stimulation to the flower painter, the whole atmosphere an overwhelming assemblage of perfume and colour. This series of sketches was made prior to a composition, to collect images and ideas and perhaps make a rough layout for a painting. The artist supplements these with photographs and details of flowers from catalogues and tries the ideas in many forms to create a firm structure in the mass of colour and texture.

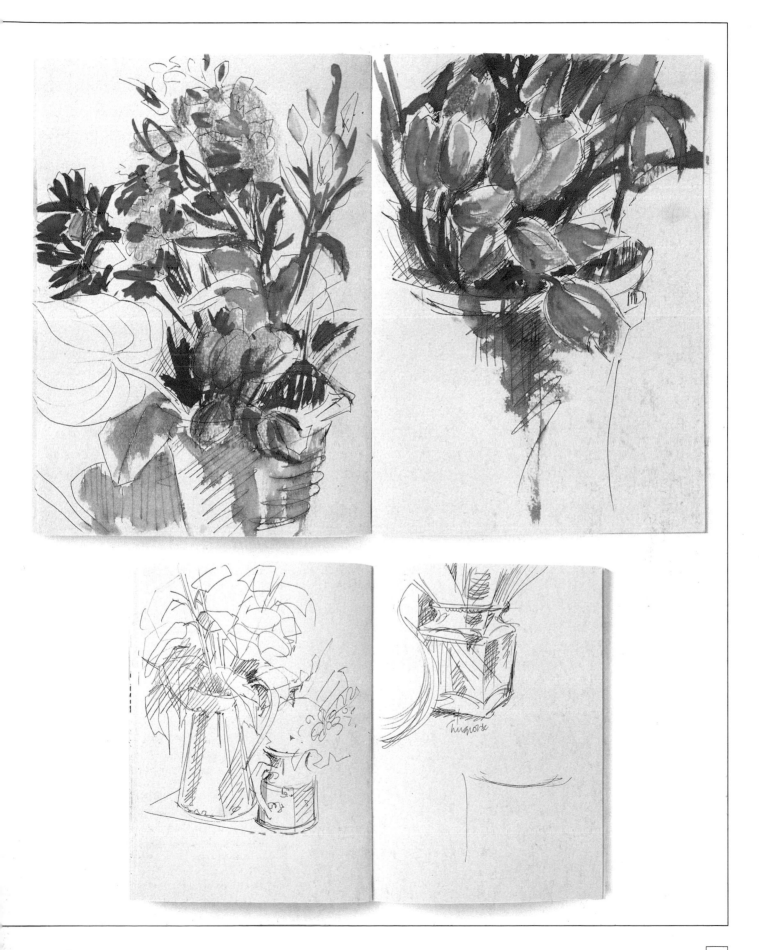

WET-ON-WET PAINTING – CARNATIONS

ELISABETH HARDEN

Wet-on-wet painting can be a most exhilarating exercise. Colour added to damp wash has a mind of its own, and the painter has only limited control. This unpredictability is part of the charm, but persistence is needed to work through and discard several failures while waiting for the moments of magic to appear. The palette used for this sketch is rose doré, vermilion, alizarin carmine, permanent rose, oxide of chromium, sap green and cobalt green.

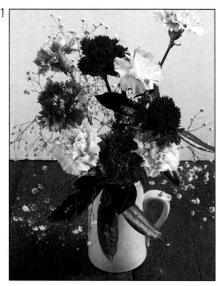

1 Carnations and gypsophila are arranged in a simple group, crowding the flower heads together to give an intensity of colour.

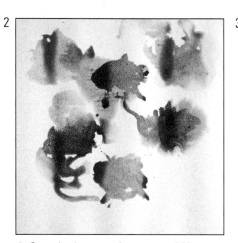

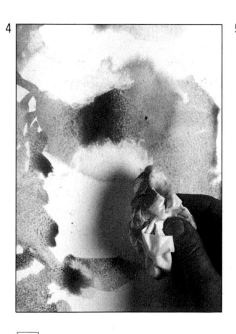

2 Stretched watercolour paper, 300gsm (140lb) with a NOT surface, is dampened with a sponge. Even the sturdiest of papers will buckle after a while. Blobs of paint have been dropped onto the paper and the buckles have caused them to pool. The artist will try and utilize this variation in colour for the tones of the flowers.

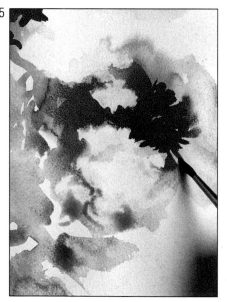

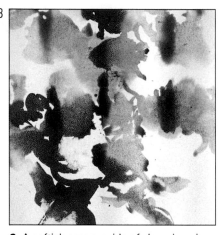

3 A softish green, oxide of chromium, is painted between the flowers. The paper is starting to dry at this point so the paint can be manipulated with a flat-headed brush into shapes of leaves and butted up against the flowers to give definition to the edges.

4 Flower shapes are made by removing paint from the semi-dry surface with crumpled tissue. This forms the basic outline of some flowers. At the same time the paints are mixing and merging together to create areas of soft colour.

5 The artist paints strong areas of alizarin carmine. Where the paper is dry it will make a crisp edge, forming the petal edges of the pale carnation. On damp patches it will merge to give a soft effect.

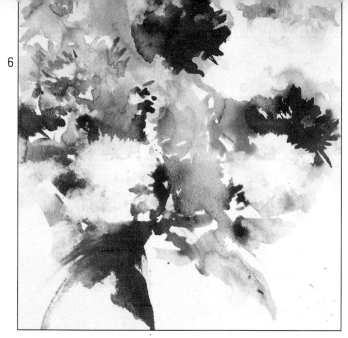

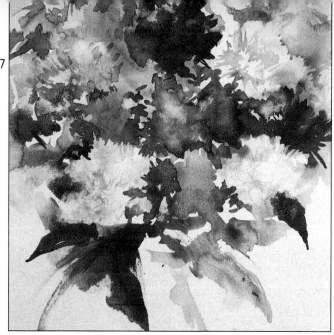

6 The spiky nature of the carnations is beginning to emerge. Redamping, painting in and removing paint with tissue builds up a loose definition of the plant. Some patches will work better than others, and by concentrating on these, the "happy accidents" can be exploited.

7 A pale yellowy green is washed in and pushed with both brush and hairdrier into sharp edges which form the outline of the palest flowers. This is a way of using "negative space" to form the body of the flower. The predominant colour in the two pale carnations in the foreground is a pink frill that forms the edges of the petals. Threads of paints are applied with a fine brush.

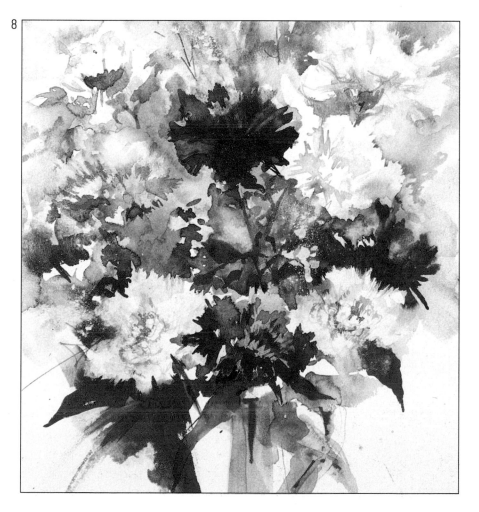

8 A third shade of green, cobalt green, forms the stems, flower calyxes and establishes the rudiments of a jug. A light spatter of white paint gives an indication of the gypsophila. Reassessing the exercise, the artist feels that texture rather than composition has been the more successful outcome. At a second attempt she would avoid the row of three flowers in the foreground, give the jug more substance and spatter a stronger sparkle of white gypsophila with acrylic paint. But, after all, trial and error is part of the painting and sketching process.

BASIC COMPOSITION

The urge to paint flowers can be triggered off by almost anything. Perhaps it is a glimpse of a stunning combination of colours that cries out to be painted or a group of flowers whose shape is particularly appealing. Perhaps you just need to paint. Whatever the reason for creating a picture, it will be both easier to paint and visually more successful if the composition is carefully considered. Composition is the arrangement of visual information in a manner that pleases the eye. It is the arrangement of the subject and the space around the subject within defined boundaries – the edge of paper, board or canvas.

Composing is sometimes just a starting point and things happen along the road that alter the original concept – a mass of colour that becomes too overwhelming as the painting progresses, an object that does not seem to fit in, perhaps a flower head altering dramatically by opening up or inclining with age. Accepting that changes might happen adds an excitement to the project. Being prepared to alter the plan as the painting progresses is likely to produce a more satisfactory and fresher painting in the end.

CHOOSING AND ARRANGING THE SUBJECT

For the flower painter choosing a subject is easy. But pause a little before making a decision. There is a temptation to set about painting a complicated arrangement of a large variety of flowers in the assumption that such mass of colour and shape is essential for a complete picture. Very often, too large a group can result in overkill; too many shapes and colours bombard the eye and leave it bemused. A few flowers in a simple vase can have great impact, allowing the plant to display itself fully – the inclination of its stem, the shape and texture of leaves and the subtler aspects of its personality.

Flower painting need not be limited to blooms. Grasses, seed pods, twigs and dead heads have distinct shapes that make a pattern in themselves. Alongside his exuberant fresh sunflowers Van Gogh drew a series of gnarled dead flower heads, which make an even more potent image than the brilliant yellow blooms.

As an alternative to fresh flowers, dried flowers can capture to some extent the character of their living equivalent. The desiccated quality adds a particular dimension to a painting, even though the living flow of life is missing. The colours of dried flowers are interesting, too, and this type of painting utilizes the subtle earth colours in the palette that are infrequently used.

Flower painting need not be limited to a conventional

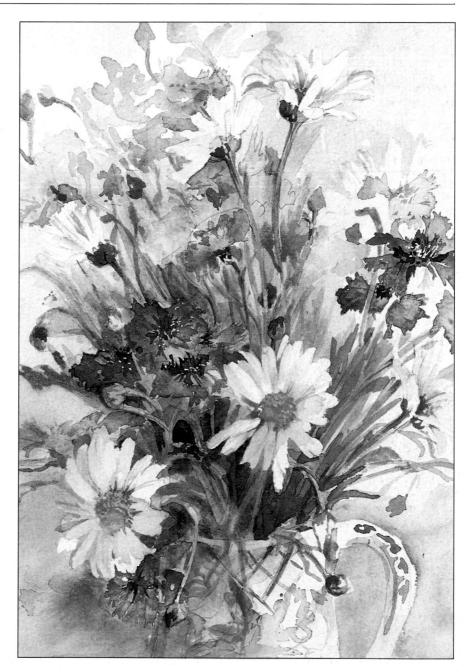

ABOVE The flowers occupy a central position in this painting by Elisabeth Harden, but by cropping the jug the artist draws the eye into the group, and by the elliptical arrangement of the daisies among the cornflowers strikes an asymmetrical balance. Subtle touches of colour enliven the whole – the yellow centre of the flowers is echoed in the soft ochre background. There is considerable variation in the strength of colour used for the cornflowers. Basically the same ultramarine blue is used, but in its intense form for the closer flower heads and very dilute in the background. The same colour mixed with indigo is used for the decoration on the jug.

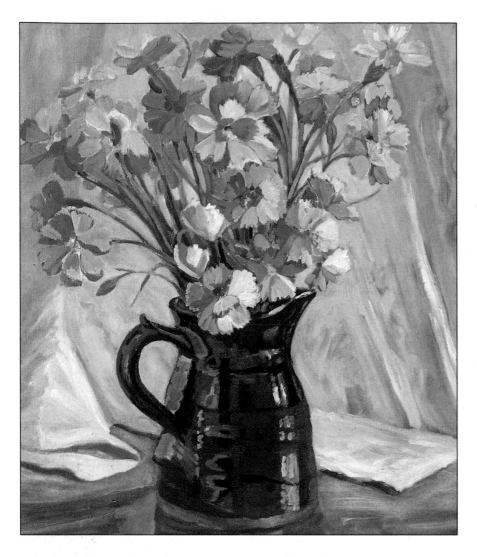

arrangement. We find them in many situations and painting a plant as found sometimes makes a more unusual composition. A bunch still in wrapping paper spread across a page could combine the fluidity of flowers and the geometric shapes of creased paper. Painting flowers outside can sometimes make the most of their amazing quality of popping up in the most unexpected places, tucked into a pavement crack, or stoutly defying the elements on a precarious cliffside, although painting in such situations is not without its hazards.

One last point to bear in mind when choosing a subject is to assess the amount of time you have. Do not attempt to paint a whole bouquet in a two-hour slot. If you cannot complete it all at one sitting recognize that flowers are living things, that they grow, expand and wither, and will inevitably have done quite a lot of this if a long period of time elapses between painting sessions. Cézanne took so long over his paintings, sometimes many weeks, that he often resorted to using silk flowers and wax fruit as his dummy subjects.

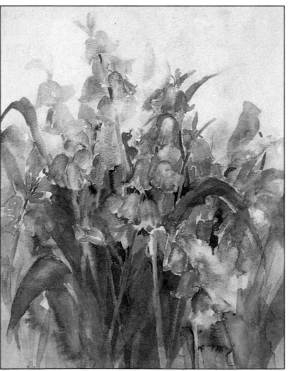

HOW TO ARRANGE THE FLOWERS

Every flower has a personality of its own. Part of this identity is related to the way it grows naturally. It helps to echo this in arranging a composition, letting the flowers flow as they do in nature. Consider the drooping habit of some plants like tulips, the erect nature of lilies and irises, the blowsy, tumbling quality of roses, or the shaggy legginess of chrysanthemums. Wild flowers work best as a haphazard mass, jam-packed into a simple jug or basket, while orchids need singling out to exhibit their extraordinary exoticism. So the arrangement of the flowers is vital in showing them to best advantage.

The choice of container for flowers depends very much on personal taste, and often the painter has accumulated a collection to suit many purposes. The size, shape and colour of the container must complement the flowers, neither overwhelming them by its bulk nor dominating them by its colour. If the lines of the flowers and the flow of stems are echoed in the container it will add a unity to the whole.

Different containers have particular qualities that can enhance a composition. Ceramic will absorb colour and show shadows; curved metal will reflect light and distort shapes. Glass containers can become a painting subject in their own right, with reflections, distortion and transparency. A plant in a flowerpot has a different identity – the thrust and flow from its roots embodies the essence of the living plant.

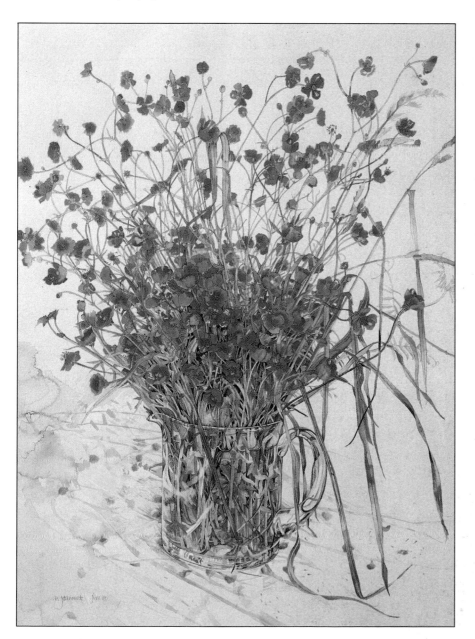

ABOVE **This bowl of cyclamen, painted by Sue Merrikin, captures the vigour of the growing plant – the thrust of the stems and the inclination of the flowers.**

LEFT **Rosemary Jeanneret painted this remarkable study of buttercups. The group loses nothing of its freshness by being described in such detail. The delicacy of the tiny flowers and their particular manner of straggling, haphazard growth is accentuated by their mass. There are definite lines of composition; the wilting grass leaves on the right lead the eye down to shadows and through these into the bulk of the flowers.**

COMPOSING THE GROUP

When you have decided what you wish to paint, think about the balance of the group and the arrangement of colour. If there are only a few flowers, or if particular flowers become the centre of attention of the group, then choosing an odd number rather than an even one tends to make for better balance. Try using more than one container in the composition or adding objects that enhance by their shape or colour – perhaps some fruit or vegetables. Another option is to see how the group looks when you lay some of the flowers beside the container.

Generally, painters set their arrangement on a table below eye level. This allows the curve of the container to give the composition a more three-dimensional appearance. It also allows the surface on which the group is standing to be used in the composition, utilizing the texture of the surface or the patterning or folds of a cloth.

There are certainly no hard and fast rules about composition, so move things around until the arrangement pleases you. Setting up should never be hurried – it is yet another aspect of the pleasures of painting flowers.

ABOVE Jeni Sharpstone's oil painting of daffodils contrasts the delicacy and haphazard petal growth against the dark, formal patterning of an Oriental carpet.

LEFT Foxgloves and roses combine to make a riot of soft colour in this glorious composition by Sue Wales. Cropping the top of the group makes it more intimate, and allows the eye to focus on the darker depths rather than follow a divertingly busy contour. Placing some of the flowers beside the vase gives the group a feeling of richness and plenty. She has orchestrated the colours in a masterly way and unified the composition by repeating the soft pink throughout.

HOW TO LIGHT THE SUBJECT

For a simple group side lighting, perhaps from a window, will give sufficient variations of tone and will establish shadows that give a composition weight. Take these cast shadows into consideration because they can become an important part of the pattern. You can of course experiment with other types of lighting and this is dealt with in detail in Chapter 8.

BACKGROUNDS AND SETTINGS

A question that is often asked is "What shall I put as background?" In complicated compositions the shapes and colours in the background form an integral part of the pattern as a whole. This will be considered on page 109.

For a simple composition the background is secondary to the main group and its sole purpose is to enhance colour and shape and to set the composition in space. Looking at the work of other painters with a particular eye to background will show the means they have chosen and how it has worked. The sumptuous flower groups painted by Dutch Old Masters tended to have dark, plain backgrounds to show off the intricacy and brilliance of the flowers. The flower studies of the Impressionists were generally very simply composed, backed by soft colours and with perhaps a few lines of a table described to set the composition in space.

BELOW In a simple group the background often takes a secondary role. This case is different. Sue Pendered has created as a foil to this group, *Hydrangeas and Amonite*, a background of subtle complexity. She uses various materials, pressing them into drying paint and experimenting and reworking until the desired effect is achieved.

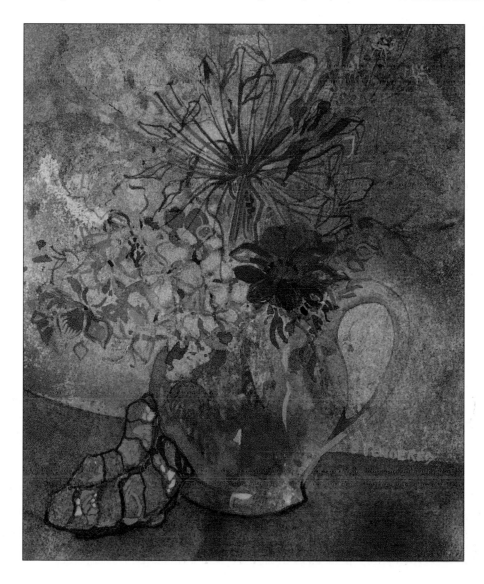

A GROUP OF ANEMONES PAINTED IN OIL

FAITH O'REILLY

Oil paint is an excellent medium for capturing the brilliant colours of anemones, and the ragged nature of their growth. There is no definitive palette of colours for painting flowers, and for the pinky/purple shades of this group Faith O'Reilly chooses a specific palette of titanium white, chrome lemon, Naples yellow, aureolin yellow, cobalt blue, sap green, oxide of chromium green, Mars violet, cobalt violet, alizarin crimson, scarlet lake, Italian pink and rose madder. This gives a good range of pinks and reds to create the different tones of the flowers. The paints are mixed with distilled turpentine or used straight from the tube.

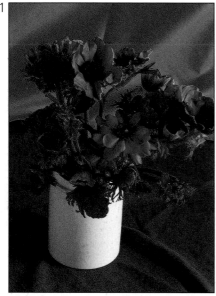

2 The stretched canvas is prepared with an undercoat suitable for oil or acrylic, and on top of this is painted a thin layer of alizarin crimson and ultramarine to create a tonal background for the group. The composition is sketched with charcoal, starting with the basic structural lines.

3 The advantage of using a mid-toned background is that the artist is working "up" to the lights and "down" to the darks. This both saves time and adds a particular richness or complexion to the finished work. Here, the lightest tones are painted in.

1 The anemones are arranged in a white jar to relieve the heaviness of a dark-toned surface, and set against a yellow background to complement the predominantly purple colouring of the flowers. Sometimes it helps to do a quick watercolour sketch at this stage, to help establish the range of colours needed for the desired effect.

4 The basic colours of the anemones are painted to establish the colour balance of the group, and to create areas of tone. The purple flowers are fairly dominant in tone, but the effect is balanced by the strong area of red and pink, which will jump forward towards the eye.

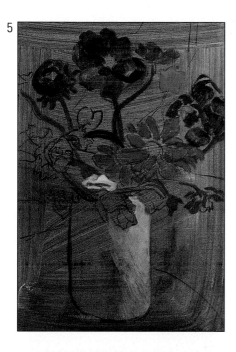

5 The principal colours of the group have been painted in and the main colour balance established.

6 Here, a dark underpainting of the surface has been worked using vigorous "scumbling" brush strokes. This lively application of paint will give texture and variety of tone to the otherwise plain area of colour.

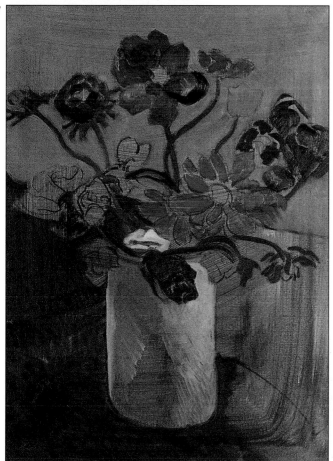

7 The artist paints a thin layer of Naples yellow over the background. Having established the whole colour balance she paints in the smaller flowers and a green-tinted reflection of the tablecloth on the side of the white pot.

8 By painting the purple and red flowers on the left of the group, the artist has created a colour balance in the whole with a trio of darker coloured flowers setting off the brilliance of the reds and purples.

Oxide of chromium green is painted around the base of the pot, and its form is modelled by dragging the paint lightly from one side to the other with a soft brush, allowing the underpainting to show through.

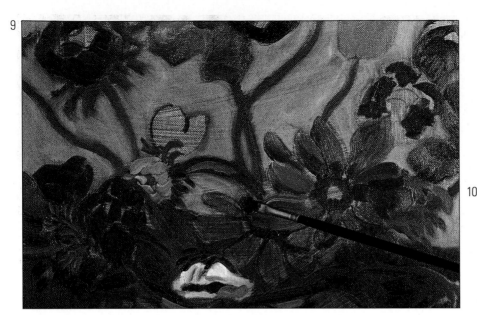

9

9 Detail is added with a fine brush, to delineate the flicker of light on stems and the feathery leaves round the flower heads. Modelling the flower heads with darker tones and picking out the flower centres gives them dimension, sets each one against each other and indicates the way they are facing.

10

10 The palette knife gives a particular texture to oil painting, allowing smooth areas of paint to be applied quickly and creating a rich background for the flowers. This builds up a thin ripple of paint around each flower and smooth patches in the background. Here a brighter yellow is being added to the background.

11 At this stage the painter assesses the work. All the components are in place, and it is time to stand back and decide what needs to be changed and where most detail is required.

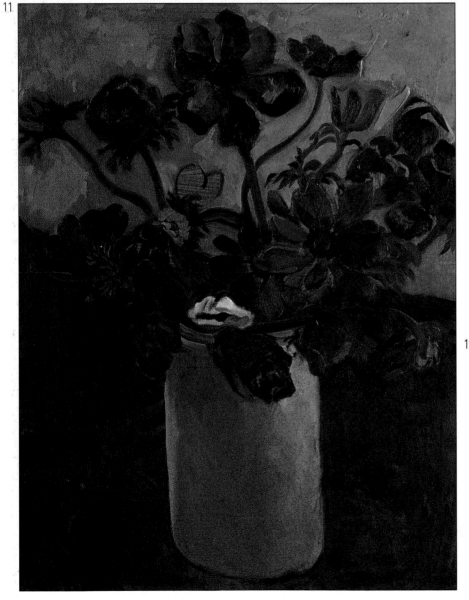

11

12

12 More colour is added to the background and flecks stroked onto flowers to denote petals catching the light.

13 A thin brush is used to add detail to the centres of the flowers.

14 Again the palette knife is used to apply large areas of paint with vigorous speed, allowing the underlying colour to shine through. The final green of the cloth gives a lighter note to the base of the composition, but the colour of the two underlying layers adds grain and density to the flat area of colour.

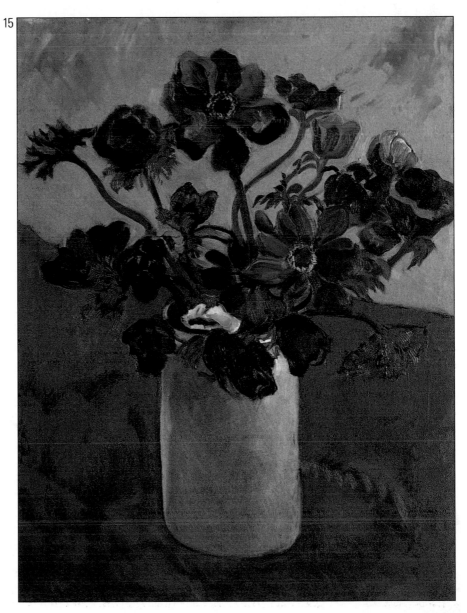

15 The finished painting has an energy that captures the vitality of the flowers. The apparent simplicity of the setting is given depth and dimension by the layers of colour, with underlying tone appearing throughout the work to give harmony to the whole.

TRANSLATING THE COMPOSITION TO PAPER OR CANVAS

Once you have chosen the subject, and combined it in a way that pleases, with lighting that defines and gives weight, look carefully at it as a potential picture. In transposing a three-dimensional group onto a two-dimensional surface, some basic rules of composition can be used to simplify the process.

Use the arrangement of objects to control the way the eye looks at the picture. Lines of movement can be created that will lead the eye to the point of focus. These lines of movement can be made by the inclination of stems, the shape of a shadow of the fold in a cloth or by anything that gives the feeling of line. Look for the lines in a group and observe where they lead. A line through the centre of a group, dividing the group horizontally, vertically or diagonally, will direct the eye out of the picture and create equal divisions that will confuse the eye.

If the dominant object is placed right in the centre, the eye can become confused by the equal space all around. So, in principle, an unequal balance makes a group more interesting.

There are also unseen lines of structure and rhythm. Placing emphasis on particular lines of construction will serve to underline other qualities. Accentuating the vertical will give a feeling of strength; paying particular attention to the horizontal, spreading quality will emphasize solidity; diagonal lines stress movement, and cross-hatching or intertwining creates the illusion of density. Utilize these lines as well as the directional lines of composition.

One way of composing is to use a viewfinder. Cut a rectangle in a piece of stout card and use it as photographers do to isolate particular areas. By moving the viewfinder around you will avoid the diversion of a whole scene and can choose exactly what you want to paint. You will also see an approximation of how it will look on paper.

RIGHT An unequal balance in a composition will make a subject more interesting. Rosemary Jeanneret has set the jug of mistletoe at the bottom of her paper and uses the space above to give a feeling of airiness and light.

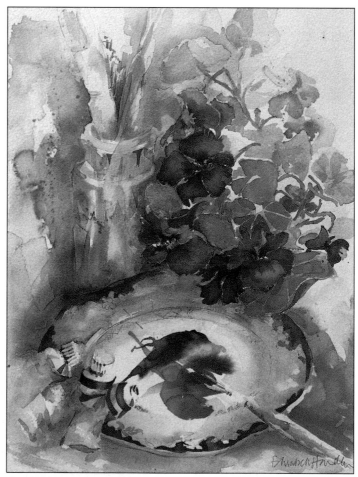

ABOVE The lines in this composition are very strong. They radiate in from three directions to the oval shape made by the plate and through the colour to the bunch of shaggy nasturtiums that form the theme of this painting by Elisabeth Harden. A harmony is made by the use of complementary colours. Orange and blue are the dominant combination, and a soft green offsets the sparks of dark red. Pale yellow in the surrounding area is balanced by a gentle touch of violet at the top of the brushes and a darker mauve in the shadows.

THUMBNAIL SKETCHES IN LINE AND TONE

Using the specific passages of the subject you are seeing through the viewfinder, make thumbnail sketches. Look at the subject from a distance, with the whole group included, and see what is happening. Position the focus of attention off-centre, or in one corner so the composition is asymmetrical. Pick up on lines that draw the eye in and curves that swing into the

composition. Look at the patterns shadows make, and experiment.

LEFT AND BELOW These thumbnail sketches (left) show various groupings. From the top downwards, the first separates the objects, the second places them in a line and the third cuts the objects too dramatically. The chosen grouping (bottom) links each object and uses a high viewpoint to emphasize the roundness. This works well, as can be seen in the finished painting (below).

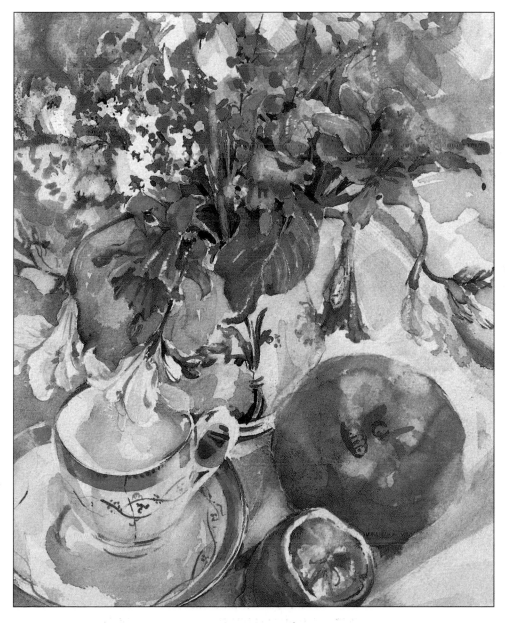

WHAT SIZE, WHAT MEDIUM

The decision to use a particular painting medium may well have been decided by your preferred technique or the materials available, but size is a consideration at this point. This will partly be guided by the subject – a busy subject painted too small will lose impact, though a single flower painted much larger than life can take on a new dimension – and partly by personal preference and the amount of time you have.

LEFT This small study of weigela measures only 12 × 12cm (5 × 5in) but the painted image appears large because it completely fills the space.

TRANSFERRING THE IMAGE TO THE PAINTING SURFACE

Some artists can paint straight from a thumbnail sketch, but it is often useful to sketch the composition in roughly. Heavy pencil drawings will leave marks on the paper and pencil lines will show through pale colours, so for a subtle watercolour structural lines in a pale colour which blends with the general scheme are best. Charcoal can be used to sketch in the structure of an oil or acrylic.

Begin by positioning the main focus of attention with reference to the sketch – the biggest flower or area of most activity – and fit in everything else around. Work on a larger surface than you think you need. This eliminates the danger of going off the paper or board and allows for altering the composition if the extremities prove interesting.

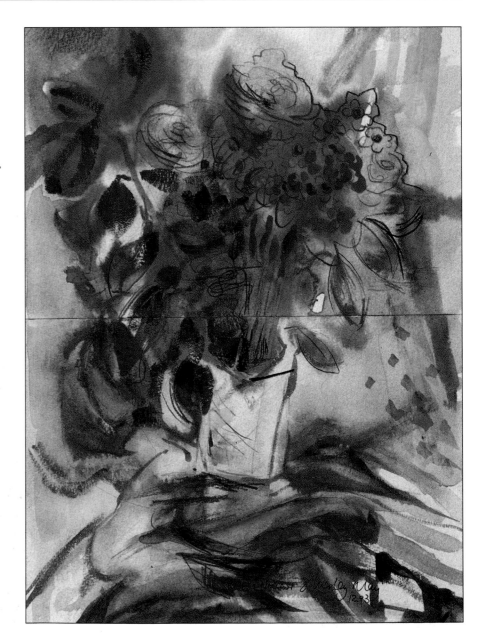

RIGHT Shirley May began this piece as a composition of flower heads using a horizontal or landscape format. During the course of painting she decided to extend the group, so added paper and completed this lively and expressive work as a vertical or portrait shape.

STARTING TO PAINT – WHAT TO LOOK FOR IN A COMPOSITION

Now that you have a group of flowers positioned in a setting, shut your eyes, then open them and look at your arrangement in a completely different way. Study it with the seeing side of the brain – the side that sees the pattern rather than the objects. Leaves and flowers will relate to each other, overlap and cast shadows. There will be a shape all round the arrangement, sometimes creating curious harsh edges, sometimes merging into a soft haze. There will be indefinable angled shapes in the group, perhaps pale spaces between the petals and leaves and dark spaces between stems, or vice versa. These strange shapes are vital to the composition. They form the negative shape around the positive. Try putting out of your mind completely the idea that before you is a shaggy yellow sunflower. What you are seeing is a complicated arrangement of shapes, locking into each other like a puzzle. What is not there sets off what is there.

SKETCHES AS SOURCES

Sketches are often the bedrock of composition, though perhaps less so in the case of flower subjects, when secondhand information may lose vitality. However, by using sketches as a basic structure, moving the shapes around, experimenting with colour and supplementing them with visual information, what emerges may be a pleasing reconstruction of a fleeting vision.

SETTING UP THE WORKING ENVIRONMENT

Painting is in some ways like cooking. The important ingredients should be close at hand because searching for some essential in the midst of a complicated procedure or when the current of creation is in full flow, is frustrating and disturbing. Assessment is an important part of the painting process. If you do not know which direction to take, leave the work for a short period of time and this will allow you to review it with new eyes. Stopping work can be very difficult; there is an inclination to worry a painting, to fill in the whole surface, to add too much detail. If you find you are doing this without achieving anything then stop – the painting may be complete.

ABOVE In this sketch the background behind the image has been coloured to form a series of interesting shapes, using the line around the picture as part of these forms. The unity of positive and negative shapes as patterns in their own right will help you compose a picture.

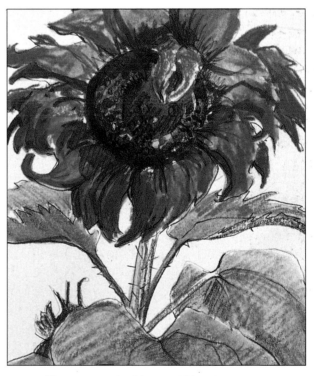

ABOVE The components of a composition are the positive shapes, the objects, set against "negative space", the empty area. The concept of negative space utilizes this space as a positive, solid entity. This sunflower, which fills the picture area, is set against a white background.

ANEMONES IN WATERCOLOUR

E L I S A B E T H H A R D E N

This is a watercolour study of the same group of anemones as in the preceding step-by-step on page 68. The artist's concern is to capture the shaggy quality of the plants and their haphazard manner of growth. The colours are permanent magenta, violet alizarin, rose madder, cobalt blue, ultramarine blue, alizarin carmine, alizarin crimson, Naples yellow, raw sienna, raw umber and Hooker's Green.

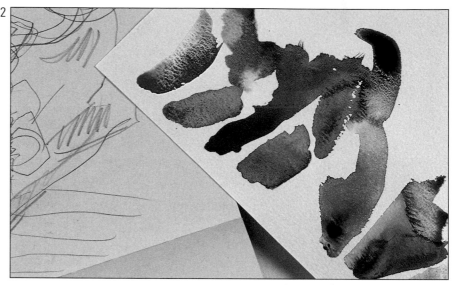

1 The composition of the group differs slightly from the previous one in a number of ways; the dark cloth has been removed from the table because it was felt to have too strong a tone for the composition, and the flowers have been repositioned so that the flow of the stems is more exaggerated.

2 Purples and pinks are notoriously difficult in watercolour, so a number of different shades in these tones were mixed to see if they approximated to the colour balance of the whole.

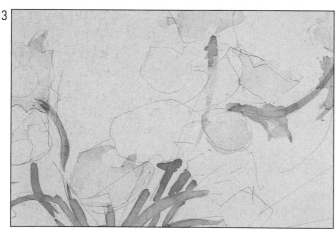

3 A thumbnail sketch of the whole, to establish basic balance and tone is transferred lightly to the painting surface – stretched Saunders NOT watercolour paper – and the stem structure sketched in with watery green paint. A pale wash lays in the basic shape of the purple anemones, forming a negative shape around a space for the brilliant pink flower. The wash is very pale at this stage, and sharper edges are formed by dropping water into the painted shapes. If too many hard edges result they can be softened with a sponge as the painting progresses.

4 More concentrated colour is dropped into the drying paint, tipping the board and using a hairdrier to control the position of the colour. The behaviour of paint depends very much on the dampness of the paper and only experience will ensure confident control.

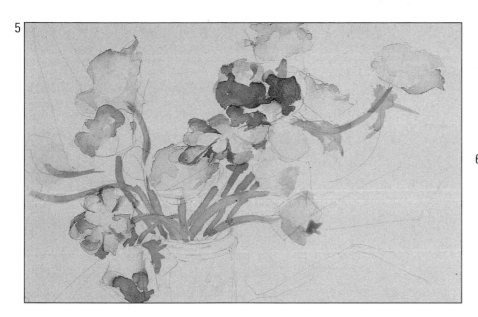

5 Basic stems and blooms are in place. At this stage it helps to stand back and see where the next shape is needed to give balance to the piece. The flowers seem to float in space so they need to be anchored into a structure.

6 Areas of shadow are painted with dilute cobalt blue, and the composition starts to come together as a group. Some painters block in this shadow structure at the beginning of the work and it acts as a scaffolding, holding the different components together.

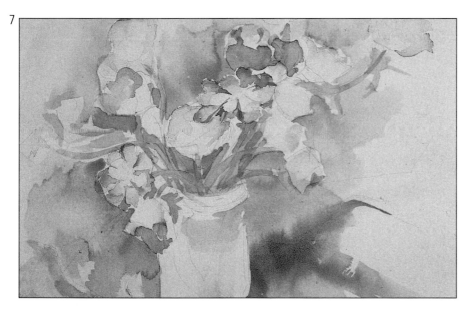

7 A wash of Naples yellow is painted round the whole. This complementary tone to the predominating purple defines the white vase and adds a warmth to the whole. At various points during the drying more colour is flooded in so that the soft background is a haze of shades and shapes.

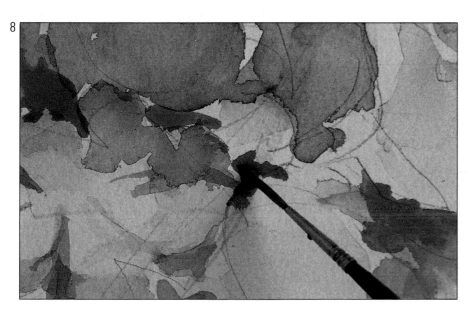

8 The whole group is pale and needs definition. Hooker's green is painted around and between the flowers, giving a sharpness to their outline, and throwing them forward in space.

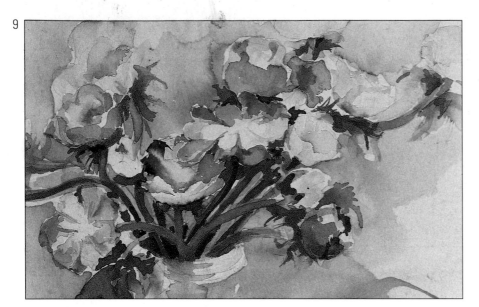

9

9 Watercolour painting is very much a process of building up layers of colour and modifying tones in relation to each other. More concentrated colour is painted into the flowers and the stems, and the dark interior of the vase is given more definition and weight.

10 Here, the artist concentrates on the heart of the flowers. Often this stage will unexpectedly bring life to the whole painting. A fine rigger brush paints in the dark centres and stamens. It helps to look very closely at the centres; often the petals are a lighter colour than the surround, and the stamens grow in a distinctive way that identifies a particular flower.

11 The flowers have an identity now and the positioning of the dark centres establishes which way each flower is facing.

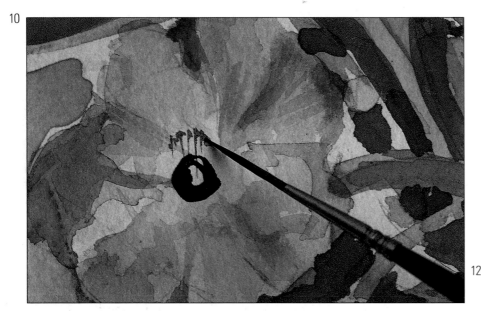

10

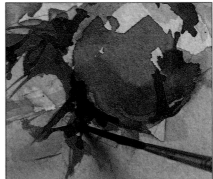

12

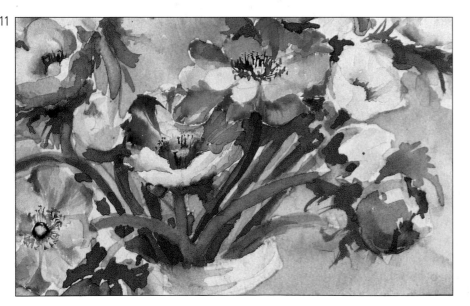

11

12 A thicker rigger brush, chosen for its dragging qualities, is used to drop in and pull darker paint into the shaggy shapes surrounding the flowers. The darker green is made by mixing Hooker's green with a touch of alizarin crimson. The flower has been painted very loosely, and the artist feels that this ruff of dark leaves is sufficient to establish its identity.

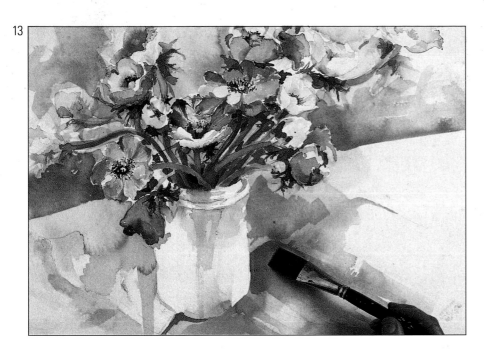

13 The composition still seems to float, so a diagonal of raw umber wash is swept across the composition. Very often, leaving the painting for a period of time will enable you to look with objective eyes and pinpoint the areas that need defining or strengthening.

14 The completed painting, which succeeds well in conveying the way in which these flowers seem to reach out from the vase, their stems twisting and bending.

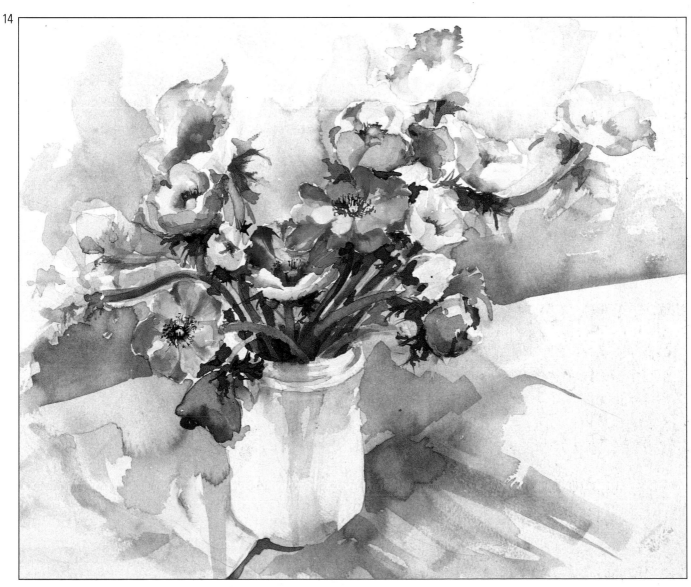

COLOUR AND HOW WE SEE IT

Flowers and colour are inextricably linked. It is no coincidence that many colours are described by flower names – rose pink, periwinkle and cornflower blue, violet, buttercup yellow, lily white. These names evoke an emotional response and a vivid mental image of specific colour.

The palette of nature can be brilliant and bold, with kaleidoscopic masses jostling for attention, or infinitely gentle, with soft, muted shades that merge imperceptibly. There is colour where you would least imagine; the petals of a seemingly white flower can yield variety of shade and tone.

In nature vibrant colours in proximity do not clash and a superabundance of flowers is thrilling rather than visually excessive. In paint brilliant colours can overwhelm each other and a huge mass of flowers can lose identity and structure. In other words, the perfection of flowers in nature becomes, in effect, one of the principal problems for the flower painter; to adapt this apparent flawlessness into a painting needs careful composition and an appreciation of the power and possibilities of colour.

It is impossible to reproduce the brilliant effect of light with pigment. We must rely on the effects of colours against each other – the interaction of colour – and on the use of tone. Much of the work of the Impressionists, the Post-Impressionists and the Fauve movement was to this express purpose – creating with colour the brilliance of light itself.

COLOUR IN SCIENTIFIC TERMS

In scientific terms colour is the break-up of light into the visible spectrum. A beam of white light passed through a glass prism separates into the bands of colour familiar to us as the rainbow, and described by Sir Isaac Newton in the 17th century as violet, indigo, blue, green, yellow, orange and red. Since that time many light-wave frequencies outside that rainbow spectrum have been investigated, notably infrared at the yellow end of the range and ultraviolet at the other. Ultraviolet is the light that enables insects to home in on plants but is impossible for humans to see.

An object has no colour until it is illuminated by light. White light comprises all colours. Most materials and substances consist of pigment that will absorb certain ranges of the light spectrum and reflect others. For example, a yellow sunflower is yellow because it contains pigment that will reflect yellow light wavelengths and absorb all others. An extremely dark flower contains very little reflective pigment so most of the light rays are absorbed. Black objects – in flowers perhaps the patterning or the stamens – absorb all light.

Blue and orange.

Red and green.

Purple and yellow.

THE COLOUR WHEEL

The spectrum of colour is often arranged as a colour wheel. This is a device created by colour theorists to explain colour behaviour. The three primary colours – red, blue and yellow – are placed as segments of a wheel so that each primary faces a mixture of the other two primaries, a secondary colour. Opposing colours on the wheel are said to be complementary to each other. Red has green as its complementary; yellow has violet; and orange has blue. Complementary colours, as the term suggests, enhance and intensify each other.

This colour pattern can be extended farther. Where primaries and secondaries merge into each other they create more subtle hues, and can be placed to great effect against the blend at the opposite side of the wheel, a yellowy green complements a pinky red.

Considering this in relation to flower painting, and in very general terms, orange flowers are enhanced by blue flowers or blue-toned foliage, for example, and red or pinks and green are mutually enhancing. The least effective of the

LEFT **These illustrations show each of the three primary colours with their complementary. Various subtleties of each colour have their balance in the equivalent complementary colours.**

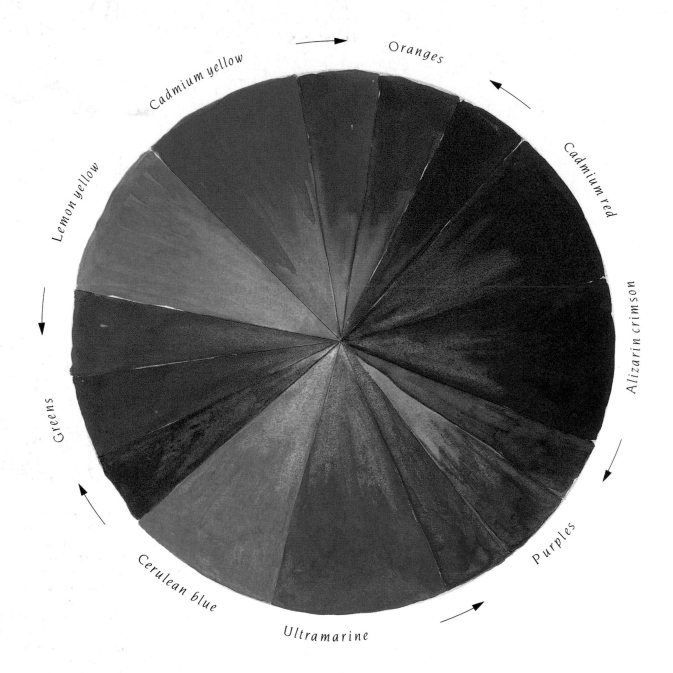

complementary combination is violet and yellow; since one is pale and the other relatively dark, the two colours are a strong tonal contrast and this can undermine the complementary effect.

Another use of the theory of complementary colours is to employ it in a softened or muted form to make the main colour more intense. Mixing a tiny touch of orange with its complementary blue will push it towards a grey, and when this is used as a soft background it will create a subtle harmony while adding brilliance to the main colour, orange, which is pushed forwards in the composition.

ABOVE **The colour wheel is a device created by colour theorists to explain colour behaviour. The three primary colours are placed as spokes of a wheel, each primary being opposite the colour mixed from the other two primaries – a secondary colour. Further subtleties are created as further mixes are made. For instance an orangey red is the complement of a greenish blue and serves to enhance and heighten its effect.**

A B O V E Two colours leap out of this composition *Blue Teapot* by Sue Wales – the brilliant blue of the teapot and the luminous patches of orange. On closer examination the painting reveals a complicated web of colour worked round the subtle nuances of these colours. The eye is drawn to areas of pattern and texture and finds echoes of the complementaries in the flowers, curtain fabric and tablecloth, and even the plate of biscuits. A sharp green flickers in the shadows and draws the eye to the bowl of red and green tomatoes. Colour and line combine to make a fascinating and vibrant painting.

L E F T This sketch shows the effect of using a muted version of the complementary colour as a background. The soft lilac intensifies the luminosity of the yellow flower.

HUE AND TONE

Colour is also defined in terms of saturation, hue and tone. Saturation means using colour at full strength to obtain maximum intensity; desaturation means diluting the colour and reducing the intensity. Flower painters in the East used to paint with saturated colours to show shadow rather than adding darker pigments.

The term hue indicates the tint or shade of colour and its variations, how much white or black the colour contains. The top illustration on this page shows a study in gouache using only the hues of cadmium yellow.

Tone is the quality of light and dark. When a coloured picture is reduced to shades of grey on a photocopier we can see the tonal values clearly. As we have said, yellow tends to be light in tone and violet dark, but other colours on the colour wheel that lie between them – orange, red, green and blue in its lighter hue – are fairly similar in tone. Assessing tone is one way of obtaining a balance in a picture.

Balance can also be achieved with colour by utilizing the affinity of two related colours, say red and orange, and balancing them with a complementary colour, like blue, which is darker in tone and is the complementary of orange.

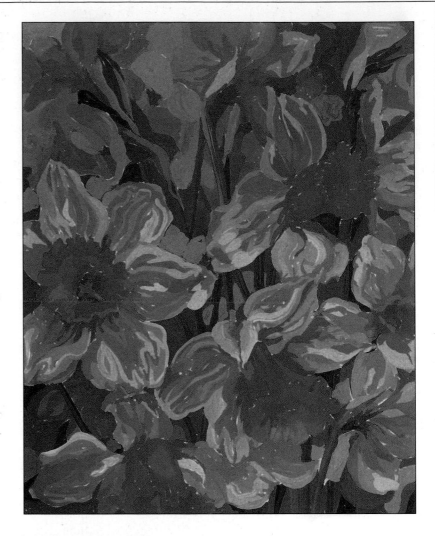

ABOVE Gouache colours can be mixed with white and black to make a whole range of hues. Here cadmium yellow has been used in its pure form and mixed in various proportions with black and white to make this wide variety of colours, from pale primrose to dark olive.

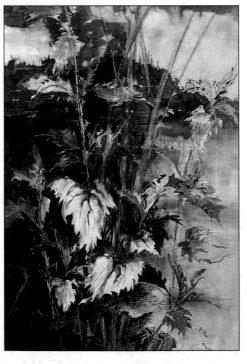

RIGHT This tonal painting of nettles uses only the shades from black to white to capture the slightly menacing and ominous quality of a dense clump of nettles. Brilliant white catches the rather cruel, jagged-edged leaves and the luminosity of a glowering sky beyond. Various shades of grey and black and textures of paint and ink explore the intricacies of the dense undergrowth.

CHRISTMAS ROSES – A STUDY WITH A LIMITED PALETTE

ELISABETH HARDEN

The purpose of this exercise was threefold: to explore the subtleties of white flowers; to paint using only a limited colour range; and to compose the group so that its arrangement within boundaries made a pattern in itself. Christmas roses are flowers of great delicacy of shape and subtlety of colour, ranging from intense plummy purple to the almost white. There is always a green tinge to their complexion. Stretched Saunders NOT 300gsm (140lb) paper is the painting surface and the palette is cadmium yellow, May green, Hooker's green, cobalt green and olive green.

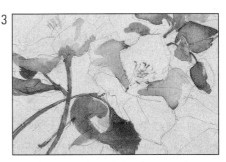

1 The flowers are arranged on a white surface. They languish out of water so the painting needs to be completed quickly.

2 A viewfinder is a useful aid. A rectangular shape approximating to the proportions of the composition is used to help fit the image into the space. Masking tape is stuck gently round the edge of the composition to create a border and this enables the paint to be freely washed against the edge.

3 Delicately coloured flowers painted in watercolour depend very much on the subtle application of thin layers of paint. Building up these layers gradually reveals the roundness of the form and here this process is shown at an early stage. Masking fluid has been used to reserve white details.

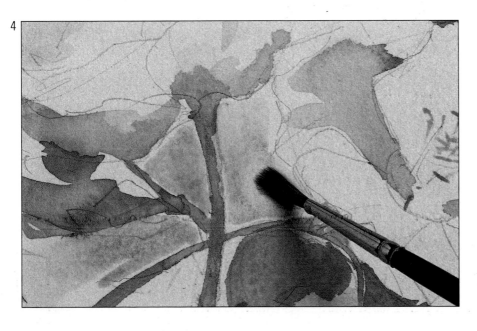

4 Cobalt green is a curiously oily colour, but it has a wonderful fresh tone and precipitates into the hollows of textured paper in an intriguing way. Here it is painted loosely with a medium sable brush to define the petals of the flowers and add a contrasting background.

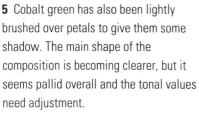

5 Cobalt green has also been lightly brushed over petals to give them some shadow. The main shape of the composition is becoming clearer, but it seems pallid overall and the tonal values need adjustment.

6 A denser green is painted and dropped in, emphasizing the areas of shadow and giving the whole painting more substance.

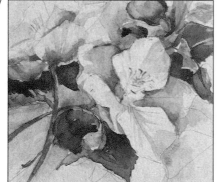

7 With each application of darker paint the artist needs to look at the whole pattern and adjust accordingly. Here you can see how the form is emerging.

8 The artist looks at the subject carefully and tries to discover the areas of darkest tone. These will both throw the pale flowers into relief and create depth. It is interesting to see that in this case the area with the most paint recedes and the part with no paint jumps forward.

9 Soft washes of colour are built up, and stronger paint introduced into the centre of the flower.

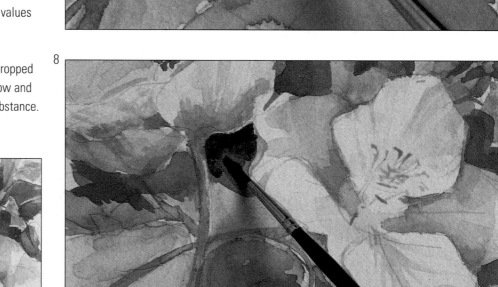

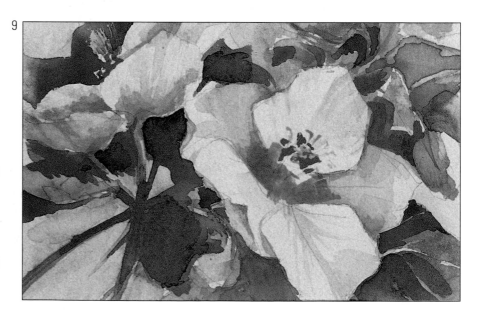

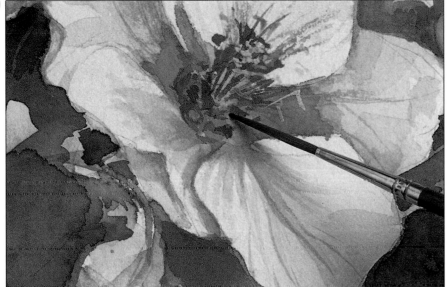

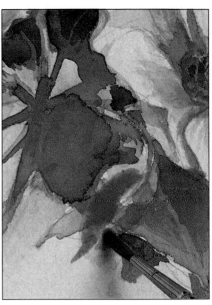

10 A very fine brush is used to pick out the dark parts of each flower centre, the masking fluid is rubbed off and the details are readjusted. The flower centres are now the point of focus for the whole painting.

11 The whole image seems intensely green, so a few touches of a warm toning colour are added.

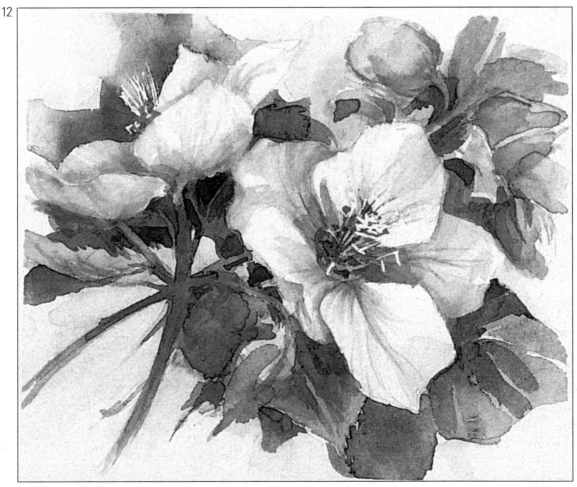

12 The masking tape is removed when the painting is completed. The resulting white surround tends to concentrate the eye more closely on the subject, and makes interesting shapes round the edge.

SPECIFIC COLOUR FOR THE FLOWER PAINTER – MIXING AND SELECTING COLOURS

Having described colour as light reflected or absorbed by pigments, it is interesting to consider briefly these pigments themselves and how they have evolved by trial, error, invention and development into the wonderful range available nowadays.

Earliest paints came from the earth itself, ochres and siennas, and pulverized minerals. Later the Ancient Egyptians tried baking these minerals and found that other colours resulted. Medieval monks sometimes used the plants themselves – the best gold for use on manuscripts was made of celandine petals and mercury (fine, as long as they did not lick their brushes). Pigments came from the most extraordinary sources: Indian yellow arrived in Europe in stinking lumps from the markets of Bengal, the dried urine of cows fed on mango leaves; painters in the 16th and 17th centuries were known to use a brown called "Mummy brown", which was made from powdered Egyptian mummies. Plants yielded all manner of colouring; madders, indigo, gamboge and sap green. Animal sources were the whelk, which produced the Tyrian purple beloved of Roman emperors; carmine came from the cochineal beetle. Painters must have worked under extremely difficult conditions, coping with the fugitive nature of the colours, the toxicity of some pigments and the cost of others.

Now all has changed. Sophisticated chemistry has produced a kaleidoscopic range of colours that are easily available, varied and, for the most part, colourfast.

The basic range for a painter consists of a warm and cool version of the three primaries. Cadmium red and alizarin crimson in the reds; French ultramarine and cerulean blue in the blues; and cadmium and lemon for the yellows. These mix to an adequate variety of shades. By adding some earth colours such as yellow ochre or raw sienna, the more translucent burnt sienna, raw and

burnt umber, and a dark grey-blue such as Payne's Grey, a huge range of colours is available. Oil, gouache and acrylic require a good quality white, usually titanium white.

The flower painter has specific requirements, and needs to be able to mix a wide range of greens, and obtain very particular colours in the red/pink areas, where mixing colours tends to dull their brilliance. Mauves and violets can also be difficult, and often the identity of a plant is linked to a very specific colour. Happily, most manufacturers offer an extensive range of colours.

Useful additions to the basic range might include rose doré, a warm pink; carmine, a rich dark red, permanent rose, a blue-based

brilliant pink, and brown madder. In the purple and violet range you could add permanent magenta and cobalt violet, alizarin violet and glowing violet. These colours are varied, brilliant and generally colourfast.

A good range of greens can be mixed from the basic palette, using the combination of the warm and cool primaries. However interesting additions extend the range: viridian, which used alone is very strong and staining, but mixes well and can be toned down with its complementary red to a dense black-green; terre verte; cobalt green, a thick turquoise green; olive green; Hooker's green; and brown pink, which is a yellowy olive colour.

With some experience and experimentation each artist will arrive at an appropriate palette. It is interesting to take note of what each painter in the step-by-step demonstrations has used. Their palettes will include particular favourites that are used much more than others and which contribute to that unquantifiable quality – individual style.

OPPOSITE AND BELOW A colour chart is an immensely useful and speedy reference. Painters often build up a collection of paints – even though they will generally use only a limited number – and record the details of each colour, in its saturated and dilute form, with the maker's name and permanence rating. Flower painting sometimes requires specific colours in the pink/red and green ranges, which are difficult to achieve by mixing.

SUBJECTIVE COLOUR – WHAT IT MEANS TO DIFFERENT PEOPLE

Scientific analysis of colour is interesting, and theories can solve certain problems, but colour also has an emotional, spiritual and social dimension in life and art.

Colour means different things to different people. The Ancient Greeks identified it with universal harmony, and associated various gods with particular colours. Tibetans link colour to geographical direction.

Australian aborigines respond to only a few colours, principally the earth and sky colours that surround them. Eskimos, perceiving their world against an overwhelmingly white background, are able to differentiate between a great number of shades of white.

Colour has long been used for healing, with specific hues affecting different areas of the body and mind – pink for instance is said to produce beneficial effects on the eyes.

Goethe called the hues from red to green the "plus" side, and the hues from green to violet the "minus" side, suggesting that one is associated with a mood of zest and liveliness, and the other with more subdued and contemplative feelings.

BELOW **This group is composed in colours from within a limited range. Soft and bright shades of blue, highlighted with white, are set in a warm surround of ochres and yellows.**

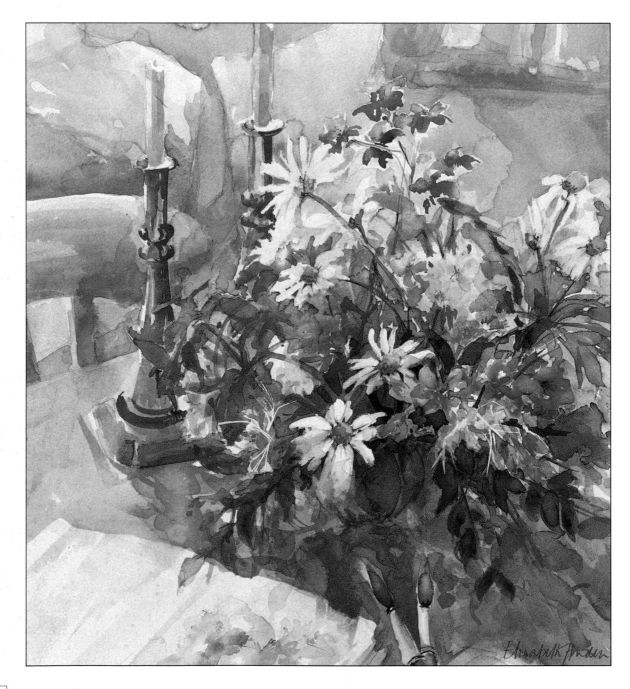

USING COLOUR FOR PARTICULAR EFFECT

Colour can be used to manipulate the eye, to lead it round a painting. Dramatic combinations of brilliant colours are exciting. Faced with two bright colours of similar tone, the eye cannot decide where to rest and flickers between the two.

Bright colour can pull the eye to a certain area, and this can sometimes be an effective extension of the composition of a painting. The basic structure of lines and tone will direct the eye to a certain point or points, but it can then be manipulated to another area by the insistent pull of a patch of brilliant colour.

A painting using colours from a very limited area of the spectrum, and using a great variety of subtle tones, will create an atmosphere of harmony. Subtle combinations of tone allow the eye to rest and to be led into an area, to explore the deeper tone. This gives the surface of the picture a three-dimensional appearance. Sometimes the addition of a spot of bright colour catches the eye and brings this area to the forefront.

A B O V E The excitement of this composition *Red, Red Amaryllis* by Shirley Trevena, lies partly in its abstract nature – a loose indication of what it portrays, inviting the viewer to explore and imagine. The stimulation of two bright colours of equal tone causes the eye to flicker between the two, unable to decide where to rest.

L E F T The accepted rules of composition are often defied in a spectacular way. At first glance the three regular pots seem to be the subject of this composition of *Anemones on Shelf* by Rosemary Jeanneret. The eye is then led round the burst of flowing blue anemones and suddenly discovers a pinpoint of red and pink at the farthest extremity. Another look at the picture reveals echoes of this brilliant alizarin crimson throughout the composition, in shadows, stems and petal tips.

COLOUR IN WHITE

Painting white flowers in some media is easy and effective, particularly when they are set against a dark background. On a darker tone, tiny sprays of flowers can be flicked with white paint, or a fragile petal stroked onto the canvas as a broken brush stroke, the starkness of contrast giving sparkle to the group. But this effect is only as you see it at the time: in reality, white is rarely white.

Look very closely at a white flower in various lights. Place it on a sheet of white paper and you will see the infinite subtleties. There will be different shades within each petal, perhaps a greener tone in the centre and a brownish tinge towards the tip. If there is light above, the petals underneath will have a shadow and this shadow will be made up of different colours. Colours nearby reflect onto the white.

Hold the flower against a window and look at the tones; the outside petals will appear pale and fragile, but where they cross one another the tone will be darker, and in the centre the colour will be anything but white, perhaps a bluey grey. Painting white flowers against light requires a firm hold on the mind to paint what you see rather than what you think is there.

Creating the form of white flowers can sometimes be difficult, especially in watercolour. Negative painting is a useful technique to use. Another device is painting a darker colour round the whole or part of a flower, which will reveal the silhouette, then adding a flower centre and perhaps a touch of shadow which will create an apparently solid form in a white space. Masking fluid can be used to great effect.

A B O V E *White Tulips* by Shirley Trevena shows how leaving blank white paper in a painting can make a very solid form, and that only a hint of shadow and detail is needed to reveal the dimension of these shapes. Their purity of shape and colour stands out against an infinitely subtle background, where flickers of white and pale pattern lend a unity to the whole.

A B O V E *White Daisies* by Sue Wales shows to great effect how a white form is seen in different situations. The daisies set against dark tones are bright and stark, their petals shown in great definition; in the shadows the form is less distinct and certain parts of the flower take on various degrees of blue shadowing. In deeper shadow the flowers are very indistinct and their identity merges totally with the atmosphere of melting shadow.

8
LIGHT

W|ithout light there is no colour. It is light that creates colour, models form and establishes mood. An understanding of the effects of light, and a knowledge of how to use it can create magic out of the mundane.

Light falling on a surface is in part absorbed and in part reflected by pigments within. Each pigment reflects back particular light rays, and this is known to us as the colour. When less light falls on a surface the colour is fainter and less true. A shadow is created when light is blocked from a surface. In this way light creates a variety of colours from differently pigmented objects and, by the arrangement of these objects in relation to the light source, makes a variety of tones and patterns.

The interplay between light and shade gives a painting its life, a pattern to its surface and a weight and dimension to the subject. It is a means of expressing a three-dimensional subject within the two-dimensional limits of a painting. Light can add excitement – a sparkle of light as it catches a petal edge, or shines through leaves – and, by contrast, give dark passages a rich density and an air of mystery.

Consider the effect of a different light direction on a simple group. A bunch of flowers, placed in a jug on a flat surface with a facing light, say a window, will look bright and clear but flat. The whole group will be uniformly lit and there will be a lack of dimension.

The same subject obliquely side-lit will look totally different. This is the traditional method of lighting a group, used by painters for centuries, either from a window, or by candlelight, and is the most effective way of establishing form and bulk. Parts facing the light source will be pale with white highlights, merging round the form to very dark areas where the subject receives no light. Shadows are cast, adding weight to the composition, and the pattern they make is often as exciting as the original subject.

Lit from the back the subject becomes even more dramatic. Deep colours and tones, barely indicative of their normal colour, will contrast strongly with a surrounding aura of light and a pale hazy background. The mood is theatrical and the effect dramatic. Inky shadows are cast in the foreground, leading the eye into the intensity of the picture. Colour and tone change in an unexpected way when seen against the light.

Hold a light-coloured flower against a bright window. Some

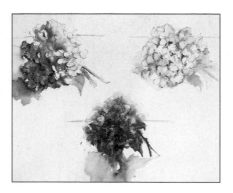

LEFT These sketches of a hydrangea head show the effect of light striking it from different directions. At the top right front light picks out each flower but tends to make the whole look rather flat and uniform. At the top left light coming from high on the right bleaches colour from the facing florets and throws the underside of the flower head into deep shadow. At the bottom back light dissolves the form of surrounding petals and gives a density of tone to areas away from the light source.

ABOVE Sunshine pouring through a large window gives an atmosphere of light and warmth to this piece. The artist, Elisabeth Harden, painted it over a period of three days, returning at the same time each day to catch the particular effects of bleaching brightness in certain areas and the patterns of cool, deep colour in the shadows. The flowers were painted freely using a Chinese brush, and a flat brush to create stripes and streaks and wedges, blending the whole with soft washes. Shadows were built up using alizarin crimson with a touch of ultramarine.

ABOVE Shirley Trevena's *Iris and Sewing Box* captures the brilliance and intensity of a back-lit scene. The outer petals of the flowers are hazy and indistinct, soft forms in subtle colours that contrast with the stark shapes of the unlit flowers. Light catches various surfaces throughout the composition and creates luminous areas of shape and pattern. The colour scheme adds to the drama, a surround of subtle purple and brown linked by a gentle patterning of red to the concentration of colour in the centre. Yellow detail enhances the brilliance of the lilacs and purples.

petals will be sufficiently transparent to allow the light to pass through them; in some parts the light will create a halo that merges with the form. Where the subject is denser, the petals thicker or overlapping, the pale colour disappears and becomes a succession of deeper and deeper tones, giving dark shadow with unexpected blues and greys.

Light is one of the elements over which an artist can have a great deal of control in the creation of a picture, with the power to direct and readjust the source of light until exactly the right effect is achieved. By utilizing an interesting source of light, the pattern made by light and dark can become a principal feature of the painting, bathing an area in lamplight while pushing the background into murky shadow, or using a chink of light to create a brilliant spot of colour, or stripes of brightness that ripple over the form, giving it a different identity.

Assess what sources of light you have at your disposal; window, top light or spots. An angled lamp is perhaps the most useful. Direct the light source either singly or perhaps in combination to give the group softness, drama, highlighting, patterned shadows – whatever will suit your ideas.

If a painting is going to take some time it is preferable to paint in constant light conditions, but a flower painter hoping to finish painting a group in the same light the following day may occasionally find only a bunch of sagging dead heads and a pile of petals. A reasonably good approximation of daylight can be achieved by using daylight simulation bulbs, allowing painting to go on late into the night if necessary.

ABOVE This sketch by Jane Dwight shows a group of fruit and flowers on a sunlit windowsill. The artist was intrigued by the warm yellow light flooding the fruit with brilliance and touching the petals of the flowers.

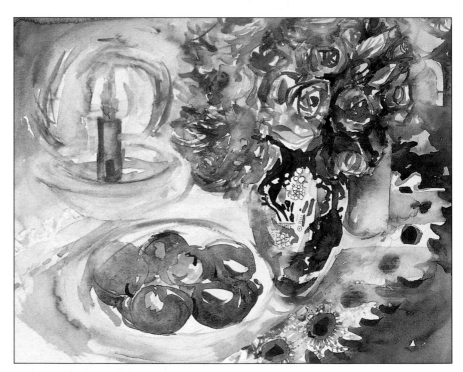

ABOVE Candlelight can be an interesting source of light. It has a warm, yellowish glow, illuminating only a small intimate area and creating dense inky shadows. The light flickers and gives the feeling of catching the scene for a very limited time. This sketch by Jane Dwight contrasts the halo of gold round the light source with the dense cool purple of the shadows. Threads of gold illuminate the light-facing edges.

EXTERIOR LIGHT

Painting outside can be a different matter altogether. The weather rather than the artist is in charge of the light source, and patterns of light and shade will change all the time.

The light at different times of day has a dramatic effect. Morning light is tinted with the blue tones left from the cooler atmosphere of night. Bleaching midday sunlight from above, which bleeds out colour and leaves intense shadows, can in an instant give way to broken light or the uniform flatness caused by cloud.

At the end of the day pinks and golds of sunset and the dust in the air leave a glowing haze. Photographers tend to do much of their outdoor work in the morning and evening because of the softer, more forgiving light.

BELOW Elisabeth Harden started to paint this composition, *Lobelia and Geranium*, as a view down a garden, but became increasingly attracted by the patterns and colours created by the brilliant overhead sunlight. It became necessary to paint the lobelia as an overall mass and then to pick out details, otherwise the plant would have become bitty and fussy. The areas of pattern on the pot are echoed in the patches of shadow and light on the table and the patterning on the fabric. Subtle reflections of colour are echoed round the composition.

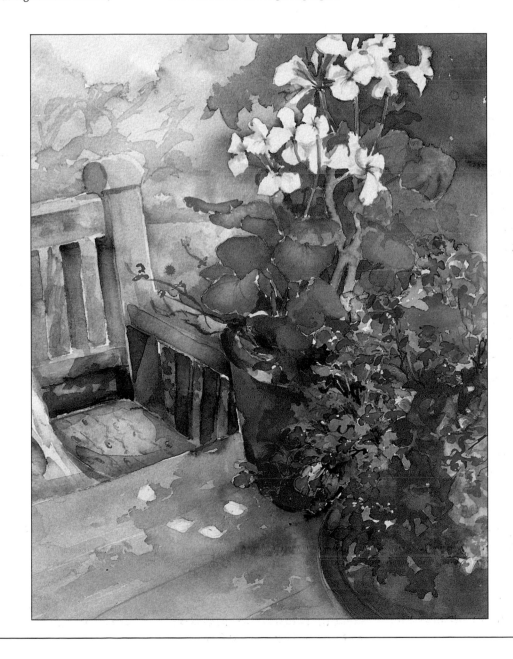

LIGHT AND ATMOSPHERE

In the 17th and 18th centuries, Claude Lorraine in France and Turner in England started to paint atmosphere in terms of light. Turner's canvases – flecks and swirls of colour creating a haze round an indistinct form – are a powerful evocation of atmosphere.

It was not until the time of the Impressionists in the late 19th century, and later, that the nature of light itself was investigated. Painters such as Monet, Renoir and Manet created luminous, glowing paintings of flowers and gardens using many flickering colours as a means of expressing the atmosphere of light.

Light is linked very closely with atmosphere. Atmosphere is a rather unquantifiable quality. It describes different weather conditions, times of day, seasons, amount of dust or water vapour in the air and temperature, all of which can vary the appearance of a subject. The resulting light conditions in turn affect the mood of a piece. Atmosphere is also linked with the way you feel about a subject, scene or situation.

Compare the mood of a composition of pastel-coloured flowers, illuminated with a soft diffused light, and a group lit with stark light from a specific source. The first has a mood of calm and tranquillity and subtle nuances of colour flicker in a misty glow. The other is sharp and brilliant; flowers stand out starkly against shadows.

B E L O W This composition tries to capture the speckled effect of brilliant sunlight on blossom. The Impressionists often painted with dots of colour, using them to describe the flickering light round a form rather than the object itself.

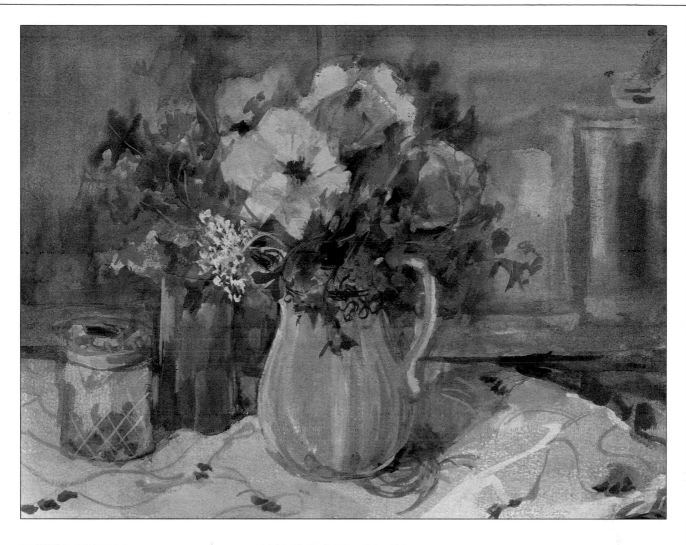

ABOVE The atmosphere of *Last Summer Posy*, a gouache by Sue Wales, is gentle and contemplative. The artist has avoided any dramatic source of light and created infinite subtleties of shade within the group. The haze of cool light emphasizes the luminous colours of the flowers, and leaves some forms as indefinable shadows. The background is a subtle mix of deeper colour, giving a loose form to some objects and an overall air of mystery.

LEFT Here the artist has chosen to illuminate the composition with a brilliant front light. *Night Flowers* by Shirley May uses the intensity of night to throw up the silhouettes of the shaggy chrysanthemum, but has employed subtlety of shade and vibrant flecks of colour to enliven what could be a flat background.

SHADOWS

For each source of light there is an appropriate shadow and each shadow has an identity of its own. Shadow is not, as might appear at first glance, a uniform dark area on the opposite side of light. It is made up of umbra (total shadow) and penumbra (partial shadow), and in each part there can be great variety of tone and colour, contrary to the frequently held assumption that shadow is made up of tones in the grey/black range. Look at the shadow to find where the darkest part is and see how it is coloured, look at the subtleties and pattern in the palest part, and see how the whole merges with the light, sometimes creating a stark line, sometimes a gentle fusion.

Take particular note of shadows in flowers and the particular colours you find there. Painting greys and blacks can often deaden the life in a flower. Shadow is, in principle, a more neutral tone, which throws the bright part into relief. Using a deeper tone of a colour, for instance alizarin crimson to make shadows in brighter red, and adding touches of blue, or perhaps the complementary green, will emphasize the brilliance of the brighter parts, and throw the subject into relief without dulling and deadening the appearance.

As mentioned previously, observing how other painters have coped with problems is often revealing. Botanical painters in the past used colour in its saturated form to create shadows areas. Other painters, such as Toulouse Lautrec, used brilliant, cool colours like turquoise and purple to make the darker areas recede. Shadows help establish the spatial location of an image, and in doing so can help fill dead areas like that at the base of a vase of flowers. They can also be an interesting part of the pattern in their own right, and the effects of light passing through different shapes can be used as an important patterning device. Light through lace curtains creates freckles of darkness on a surface, and using the patterns of light and shadow created by reflection in glass, mirrors and shiny surfaces, can be fascinating and complex.

Light is one of the key components in a composition; experiment with using it in different ways and enjoy the result.

ABOVE **A jug of daffodils waiting on a kitchen surface inspired this study of reflection by Elisabeth Harden. The various layers of shadow and reflection that make up the abstract pattern of shape give only a hint of the identity of the flowers above, but this is part of the attraction of the whole. Ambiguity in a painting is intriguing; not knowing exactly what a subject is takes a composition out of the area of reality and into the realms of the imagination.**

LEFT Rosemary Jeanneret has used shades of lilac and blue to create the subtle pattern and varied layers of these shadows. This is a detail of *Buttercups,* and shows the meticulous care with which the artist has observed the nuances of pattern created by light. Shadows vary enormously in their intensity depending on a number of factors – brightness of light, distance from the surface and how the object faces the light. Notice also the patterns of light and shadow on the glass jug and the colours the artist has used to portray it.

BELOW Light can create exciting shadow patterns that can become an integral part of a composition. Christine Holmes' work depends very much on flat pattern, and she articulates the surface of her paintings into a fascinating jigsaw of shape and colour. In this composition her use of dark grey shadows has an enlivening rather than a deadening quality, adding dimension to the shapes, echoing their form and anchoring the varied objects into a whole. If you tried to consider this composition without the shadow it would be confusing to the eye.

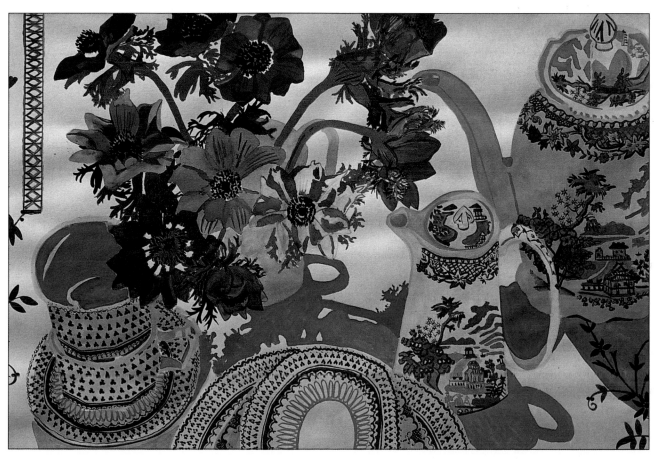

9
COMPOSING
PICTURES IN A SETTING

O nce you feel confident painting a simple group it is interesting to move on to something more elaborate – to paint flowers in a setting that forms an integral part of the composition, or to group the flowers with other objects whose shape, colour or particular significance enhances the pattern and mood of the whole. The same planning decisions must be made as with a simple composition in terms of balance, colour and tone, but the boundaries are wider, and other criteria are involved such as distance, perspective and the relevance of the flowers when they may not be the main focus of attention but an important part of a wider scheme, an interior, landscape or even a portrait.

THE LANDSCAPE OF THE INTERIOR

Consider what you want from the group; what you want the painting to say. Are you inspired by an atmosphere of hazy colour in soft light, stark contrasts of brilliance in a garden border, or the excitement of interesting juxtapositions? Perhaps you just happen upon a scene that begs to be painted, a bucket of flowers in a kitchen sink waiting to be arranged. Keep the "why" of wanting to paint it at the forefront of your mind because it is the emotional surge that will give vigour to the painting.

Sometimes you can paint there and then; more often the components need to be arranged, and the best viewpoint chosen. Setting the composition is the most important and often the most time-consuming operation. By using a viewfinder to look at the composition from all angles you will see that shadows, unrelated shapes and parts of other objects can be used to make up a pattern within the confines of the frame. Choose objects that complement the group, scour around for interesting things that relate either in shape or colour,

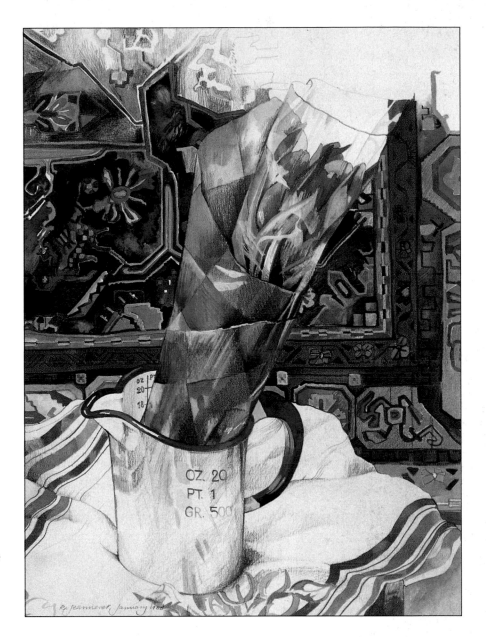

RIGHT *Wallflowers and Oriental Carpets* is part of a series of paintings in which the jewelled colours of wallflowers are set against the more subtle and sombre patterning of Eastern textiles. One type of wallflower is actually named Persian Carpet, and seeing this on a seed packet may have triggered the initial idea. Gouache has been used because of its smooth, matt quality, and the whole composition has been abstracted in to a series of flat areas of pattern, highlighting features such as the radiator for its corrugated shape rather than its rather mundane identity.

ABOVE *A Bunch of Tulips* by **Rosemary Jeanneret** is more a composition of geometric shapes than a portrait of flowers. It is the subtle juxtaposition of these shapes and colours that gives the painting its vigour – the slightly off-centre metal Jug with its delicate reflections, the diagonal thrust of the bunch of tulips in its harlequin wrapping and the flowing stripes of the cloth echoing this diagonal. Each colour reappears in the regular patterning of the Oriental carpet chosen as a background.

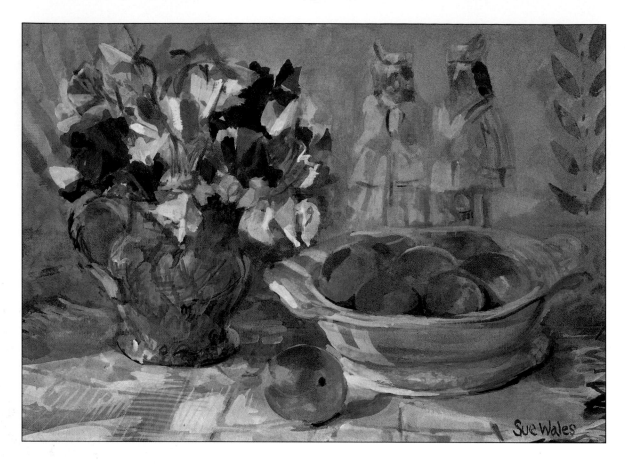

A B O V E A consideration when arranging a flower group is the shape and character of the flowers themselves. In Sue Wales's gouache painting *Sweet Peas and Peaches* the triangular petals of the sweet peas are echoed in the shape of the pottery figures and in turn the tartan patterning on the garments worn by these figures is echoed by the squared tablecloth. Yet more reflection of pattern is found in the stripes catching the side of the fruit bowl, and the curved shapes within this bowl repeat the round shape of the pink peach in the foreground.

A B O V E A large arrangement of flowers in the foreground is used here as a device to lead the viewer into the heart of the group. The blue-striped canvas serves the same purpose. The artist painted this sketch from a video of a friend's wedding and, using flower catalogues as a reference for the flower group, developed the idea into the basis of a lithograph.

or will add pattern and texture. Fabric and folds can make interesting areas of tone, and newspapers and the printed word make interesting patterns. Add objects that might seem unrelated but will add a frisson to the composition and a new dimension of meaning.

If you use a viewfinder to look at the composition from all angles you will see that shadows, unrelated shapes and parts of other objects can be used to make up a pattern within the set confines.

The next decision must be to make a calm appraisal of the subject matter before deciding what will be the point of focus. This need not necessarily be in the foreground; indeed, leading the eye all round a painting en route to the point of focus in the distance is a method employed by many painters and can make the composition much more interesting.

Use blank space and solid blocks of colour as elements in the jigsaw, and make use of the contrast of areas of great activity where there are lots of busy shapes or complicated patterning against the calm areas of single or no colour. Move the viewfinder up and down and from side to side to place the point of focus at the top or side of the frame, letting the large space left become a structural element in the jigsaw.

LILIES, ANEMONES AND GLASSCLOTH

SHIRLEY TREVENA

In this composition Shirley Trevena has arranged a few flowers and household objects in such a way that their pattern and disposition become the most important elements in the composition and the simple objects themselves take on a new meaning. She finds a visual excitement in seeing certain colours together and exploring the spatial relationship between objects and spaces. The large areas of white paper in this composition are a significant feature of the whole. Her palette is cadmium yellow, sap green, olive green, Winsor green, permanent rose, indigo, purple madder alizarin, sepia, raw sienna and black.

1 Setting up the group can take a considerable amount of time. Each part is carefully placed so that colour, shape, ellipse, line and pattern relate in the jigsaw of composition.

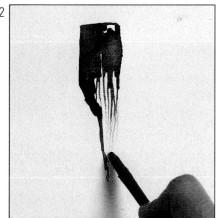

2 The artist uses a combination of watercolour and gouache. Here, strong green paint is dragged into the lines of the leaf with a twig.

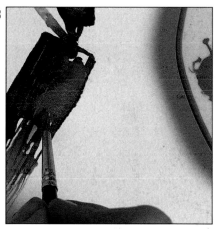

3 Cadmium yellow paint is fed into the wet green paint.

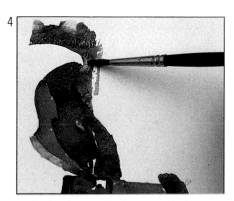

4 Further layers of paint are added to create more leaves and the stark outline of the lily petal. A strong purple defines more of this petal and is encouraged to melt into the drying green paint below.

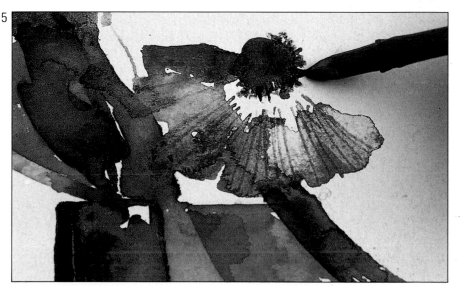

5 The same purple paint is led into the shape of the flower, allowed to merge in some parts and in others used sharply to define the form. At the same time, the flower centre is painted and the petals scraped to create a radiating pattern.

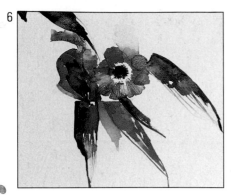

6 The form of the group as a whole now begins to appear.

7 Yellow paint is concentrated in the flower centre and allowed to spread into a few of the petals.

8 As the form is built up, more leaves are added. A squirrel brush is used to soften shapes, remove paint and blend colour.

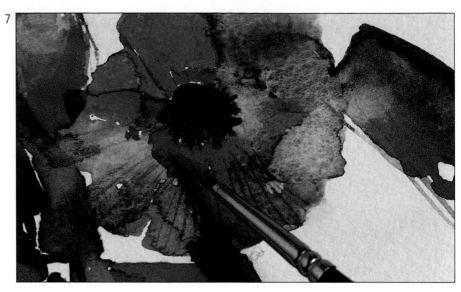

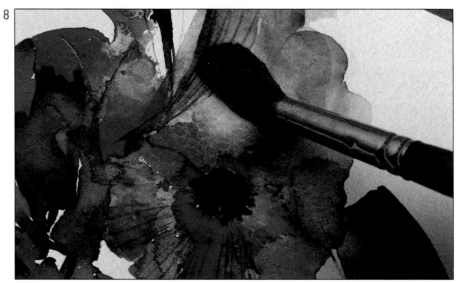

9 The lower parts of the painting are now lightly sketched in. The letters on the glasscloth are carefully drawn, and the parts intended to remain white are painted with masking fluid.

10 While the masking fluid is drying, stamens are drawn in the heart of the lily. In some cases the intense colour of the anthers is allowed to flow into the softer green stamens. A pale grey wash adds shadow to the underside of the flower.

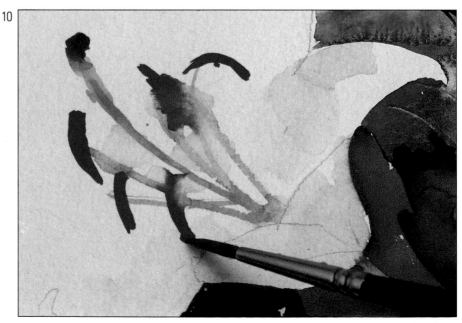

11 An important part of the whole composition is the strong horizontal. A dark sepia wash across the composition throws into relief the oblique thrust of leaves and stems. More leaves are added to emphasize this diagonal.

12 An indigo wash is painted over the masked letters to form the stripes of the glasscloth and differing values of tone are used to bring out the ripples and folds of the cloth.

13 The masking fluid is removed by gently rubbing with the finger.

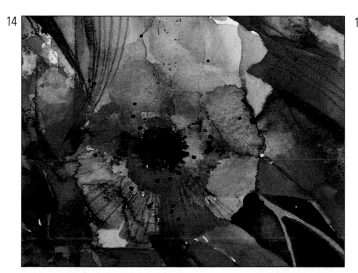

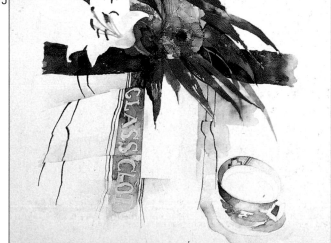

14 Dark paint flicked with a brush adds sharpness to the centre of this anemone.

15 Moving from the dense area of activity at the top of the picture, the artist uses indigo paint to shape the cup and saucer, defining only part of its form and using the lines on the glasscloth to tie it into the whole structure.

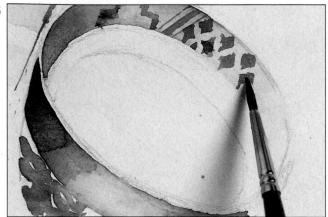

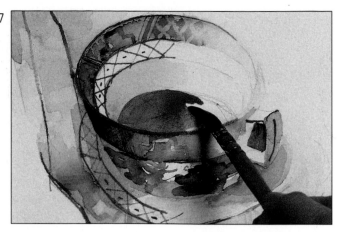

16 Detailed painting with stronger paints adds pattern and definition to the cup.

17 When the blue paint is completely dry, a thin sable brush is used to draw the fine decoration, and a thicker squirrel brush floods a wash of raw sienna paint into the cup, carefully manipulating it and adding more colour as necessary.

S. Trevena

18 The finished painting is a wonderful mix of rich colour and shapes of white. The artist has deliberately left the flower container as a blank rectangle, forcing the eye to flicker between the intensely coloured area at the top of the composition and the cup and saucer, and their echoes of colour.

PAINTING A LARGER LANDSCAPE

Painting flowers in an interior or as a group with other objects, the painter is for the most part in control of the arrangement and can shift and add as he or she pleases. If you choose to paint a wider landscape, and this may be a flower shop or market garden or a meadow, the components are already there, perhaps in abundance. The most important task is selection, and the principal aim must be to achieve a harmonious balance between foreground and background. Thus the composition becomes an intriguing combination of flower study and landscape.

One of the great pitfalls when faced with, say, a flower-filled garden border or an orchard of blossom, is to try and paint it all. But in reality, the eye does not see it all at once. It will rest on a particular area, home in on a few blossoms, and the mind will be aware of a haze of colour and light, or perhaps a dense, receding undergrowth. Just as when walking through a landscape the eye registers certain objects at first and then is led along paths of discovery and starts to notice other things, a landscape painting needs a pattern that will lead the eye "in and round and through".

ABOVE This sketch was a quick response to a mass of daffodils and narcissi grown in an orchard. A few details identify close, individual flower heads, but the overall impression is of an abundant sweep of massed spring growth.

RIGHT A field of oil seed rape is the subject of this painting by Mary Faux Jackson. The overwhelming brilliance of a vast expanse of the acid-coloured flowers was the inspiration. The artist has overcome the problem of giving depth to this expanse of yellow by softening the colour towards the distance and clarifying a few of the foreground flowers with patterns of dark greenery. The line of the edge of the field and the distant building anchors the composition in space.

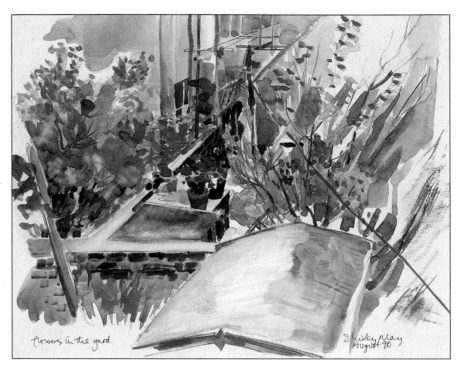

ABOVE This painting by Christine Holmes, *Lilies on a Pond,* is typical of the artist's meticulous method of working. The particular characteristic of each plant is carefully observed and expressed in a subtle variation of colour. This order gives the eye a clear route round a busy composition, focusing on the wide-open lilies in the foreground and the black depths of water between them, and then leading it further back in the picture to the two pink flowers, which stand as stark silhouettes in the dense shadows.

ABOVE The scene is a view into a backyard, where the features of an urban landscape are enlivened by a pot of brilliant orange flowers. The colour of this tiny feature draws the eye, and it is emphasized by the delicate mix of blues and green surrounding it.

So the first decision must be to decide what most interests you, and when you decide upon the area of focus, which particular spot you want the eye to home in on; this can be defined by strong colour contrast, clearly defined detail and compositional devices.

To begin with, make some preliminary drawings. These will clarify in your mind how you want to control the structure of the composition. It will help you to pinpoint areas that need to be highlighted and also the areas where soft tone and lack of detail will take them out of the area of concentration.

When you start painting, fill in areas of colour broadly, perhaps working wet-on-wet, until the basic shape appears, then home in on key areas with stronger colours and crisper shapes. Use the receding quality of blue tones to pull areas into the distance, and the brightness of reds and oranges to make features spring forward out of the composition towards the eye.

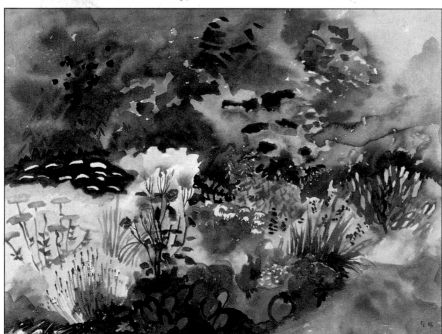

ABOVE Francesca Lucas-Clark uses watercolour in a very free and fluid manner to describe the effects of light in the landscape. Very few of the flowers in this painting are represented in any detail, but their identity is clear from the shape of a clump, the line of a stem and the odd hint of recognizable features.

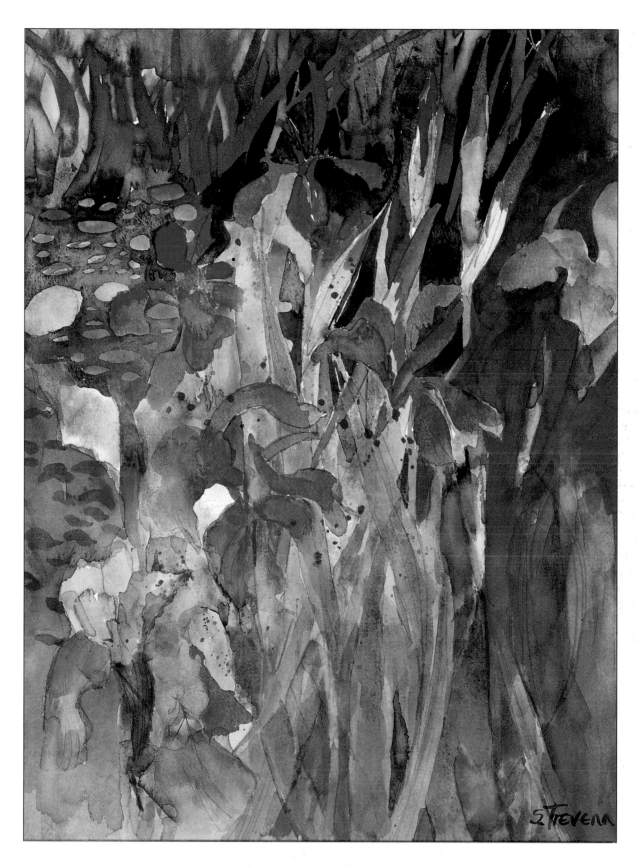

ABOVE This painting and the one opposite, top left, have plants and water as their theme. Both are painted in gouache, but the style and use of paint could not be more different. This luminous painting,

Irises by a Pond by Shirley Trevena, combines criss-crossing leaves and stems and bursting flowers, sharpening the image with jutting sheaths of bud and discs of reflection on the water beyond. Water is

very much a part of the texture of the painting – floods of loose colour give a watery feel, and the soft, spattered paint has the appearance of drops of rain on a window.

PAINTING IN THE LANDSCAPE

Painting on location involves other considerations. Having all the essentials with you is a priority, and keeping a list and a bag of basic materials saves time. There is a great deal of equipment on sale for outside work, but travelling light is much easier. Basic paints, in an easily transportable form, and with sufficient space for mixing are essential; a container for water or medium, and ideally a source of the former at hand are needed. Brushes need their bristles protected, and polythene bags act as a good cover for both oil and watercolour. Oil board itself acts as support, and watercolour blocks or paper pinned to a board give something to lean on.

The principal requirement, though, is somewhere comfortable to sit; a small folding stool will increasingly reveal its value as the painting session proceeds, and reduce the effects of damp and cramp. A hat helps, and insect repellant is sometimes surprisingly useful, though the suffering endured by the botanical painter Sydney Parkinson in the 19th century is now unlikely. When sitting on a beach in Tahiti he was overwhelmed by a cloud of flies which not only obscured his view, but consumed the pigment of his painting.

THE LANDSCAPE OF FLOWERS

The American painter Georgia O'Keeffe created wonderful images of the heart of a flower – close-up views expanded to such dimensions that they had the effect of making the viewer lose sight of the details of structure and concentrate on the essence or soul. She painted a series of paintings of "Jack in the pulpit". Each successive image in the series draws closer and closer to the heart of the flower, recognizable features disappear and the heart becomes a surreal and magic landscape.

Treating the interior of a flower head as a landscape in itself can be fascinating and revealing. A basic flower head is instantly recognizable. We think we are looking closely when we get very near the flower, but how often do we look right inside and imagine that thumbnail interior as a large landscape in its own right?

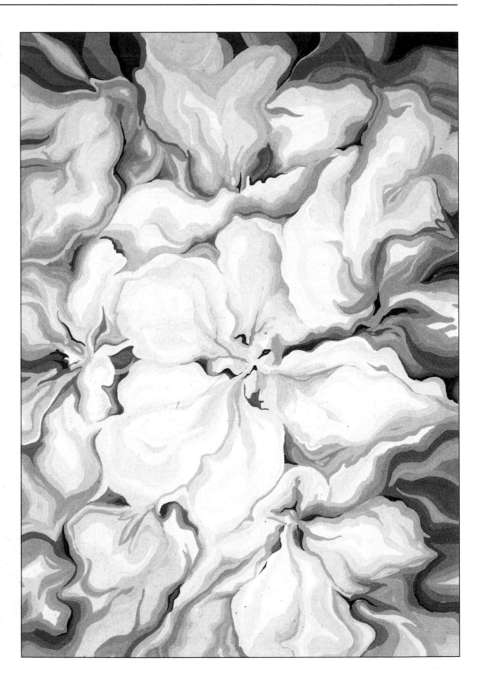

RIGHT **The artist uses subtle gradations of tone in gouache paint to explore the folds and rhythm of a cluster of apple blossom. The exercise was not principally intended as a description of the features of the plant, but rather as an exploration of the flow and movement of petal growth.**

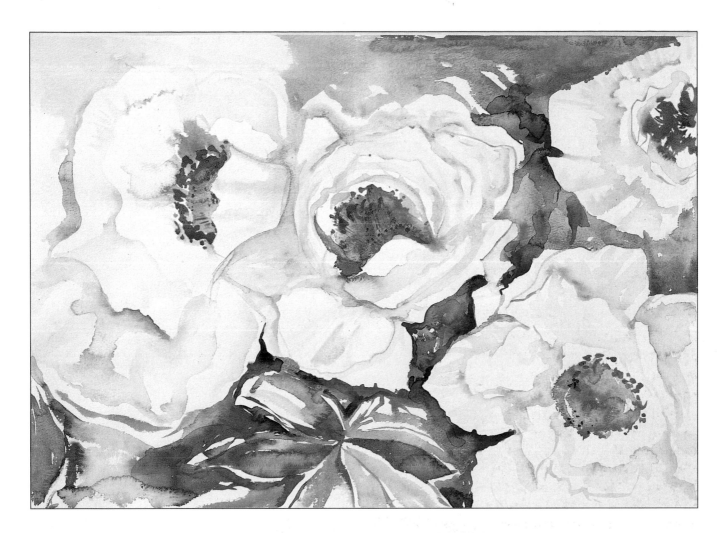

ABOVE Jane Dwight captures in this
watercolour the soft, luminous tones and
shades in the heart of a rose. Clarity of
colour and sharp areas of dark paint
describe the form with vibrancy and
freshness. This watercolour is large, and its
size gives this close-up great impact.

RIGHT This painting is very large and is
based on an enlarged photocopy of part of a
painting of poppies by the artist. Expanding
the flower to fill the whole range of peripheral
vision brings us right into the heart of the
flower and excludes the distinguishing
characteristics of external structure, which
identify it conventionally in our minds.

FINDING YOUR OWN VISION

A final chapter in a book is in principle a round-up of the ideas explored. It is easy and satisfying to assume that, having investigated these ideas, built up an experience of materials and techniques, developed a basic confidence in the use of paints and a knowledge of the subject, that would be the end of the story. But it is only the beginning. Looking back over the previous chapters will confirm that the ways in which flowers can be painted are as varied as the flowers themselves. Painters have explored the fundamentals involved in creating a painting and developed these ingredients into a very personal means of expression.

Experience of materials and techniques allows choice. It enables a painter to choose the medium that suits the purpose and the colours that particularly appeal, to develop a personal palette, and to manipulate those colours into a harmonious and satisfying fusion. Taking steps forward and extending choice is not necessarily expanding the range of flowers painted, but perhaps confining and limiting, using shapes and forms with which we have built up a confident acquaintance, liberating us from a hesitant encounter with something new.

Many artists return again and again to a particular theme, using the same favourite objects, colours and shapes. Familiarity enables them to push the idea to the limits and to discover new means of artistic expression. The painter Jennifer Bartlett has expanded and evolved a single subject, a garden in the South of France, into a colossal series of works, expressing in a variety of media her direct response to this setting under varying conditions, from different points of view, and developing the theme in concept and scale into more varied media still – woodcut, silkscreen and metal.

Consider works already completed and experiment in varying the interpretation. Many artists find that reworking an image in another medium is a good means of dismissing the staleness of familiarity. Trying a new medium will force you to explore and concentrate on different elements, and can be liberating and thought provoking.

Watercolour depends upon the luminosity of white paper shining through thin veils of paint, upon the often haphazard pattern made by water and paint and upon a

ABOVE The patterning and colours of this group of primulas touched a chord in the artist's mind and linked them with particular images and objects. A much-loved wooden elephant makes an appearance in the composition, and the image of an Indian figure from a postcard is repeated in triplicate. One of the artist's favourite subjects is the medieval angel seen at the back of the group. Christine Holmes has used flat patterning in the manner of Oriental manuscripts to create a rich and evocative image.

ABOVE *Irises, Fish and Lemons* by Christine Holmes started life as an exercise to try to make a composition from three objects whose identities and form were very varied. She has painted several versions of this interesting mix, combining the three into a recurring pattern, intertwining the characteristics of each into an abstract jigsaw, but retaining patches of their particular identity.

ABOVE Shirley Trevena abstracts the visual essence of a few flowers and fills this composition with their brilliant colours. The title of the work is *Blue Glass Jug of Flowers,* but the exciting element is the abstract disposition of all the pieces. We are not sure which flowers are in the jug and which are outside, but it does not matter; the feeling of the whole is of the exuberant vibrancy of flower form.

certain amount of considered planning. Try the same subject in gouache on toned paper, using the denser paint to build up dabs and dots of broken colour and allowing the tone of the paper to show through. Gouache allows great subtlety of pastel shades, and the chance to travel up and down the tonal scale, and also a greater intensity of colour than watercolour. Oil paint and acrylic will each add another dimension to the same subject, brilliance of colour and the rhythm of textured brush strokes. With acrylics whole areas can be altered at a stroke and random splashes of colour and brilliant highlights added at will.

However, the choice of a particular medium does not mean that you have to stick rigorously to it. Combining different materials can produce interesting and exciting results that emerge through the trial and error of experimentation, though some media combine much more happily than others.

Soft pastel used over watercolour can add vigour of line and surface texture, though it should be used with a light touch.

ABOVE **Shirley May's painting of *Freesias* combines watercolour, gouache and pastel, using the matt, chalky quality of the pastel to add streaks of broken colour, and the sparkle of varied texture to the surface of the painting. The artist works very fast, often making numerous images of the same subject, and builds up her composition by responding instinctively to the flowers with a variety of materials rather than trying to capture an accurate, definitive record of her subject.**

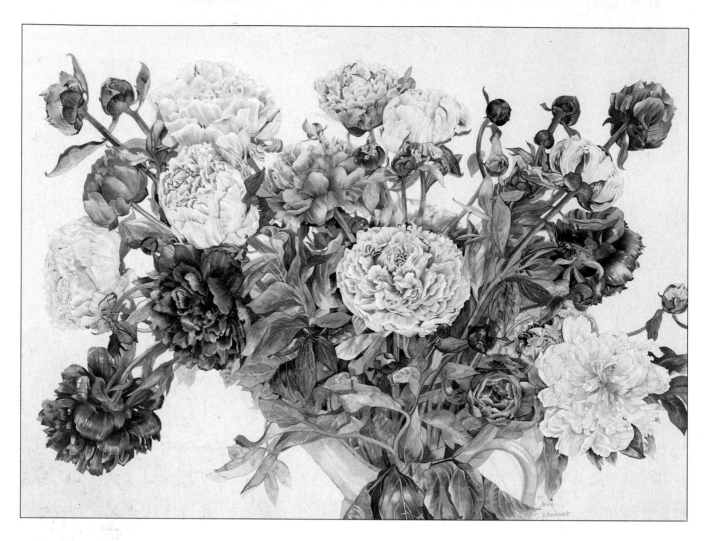

Crayon and watercolour used in combination delineate form and can give a more controllable subtlety of colour. Watersoluble crayons can be wetted to make fluid paint or used in a linear manner. A good example of this successful combination can be seen in the step-by-step demonstration on page 48.

Acrylic and watercolour used together can exploit the qualities of each, merging the stronger, denser tone of the water-diluted acrylic into the watercolour, and using its clarity of line and strength of colour to pick out sharp detail. Combining patches of rich, matt colour with soft fluidity can be very effective.

Other combinations work well. Often the need to use different media will arise in the course of a painting, and you should never hesitate from adding as seems fit. Mixed media can combine the most unexpected of bedfellows and the spontaneity of creation can inspire you to utilize and incorporate the most mundane of materials.

Trying different media and combining materials does not necessarily mean the purchase of a new set of equipment. Some of the best and most exciting materials may be close at hand. Twigs can be used to pull paint in different directions, to print lines or to manipulate oil paint. An image drawn in candle wax or oil pastel will show through thin water-based paint. Paint sprayed over leaves will leave a silhouette on the paper.

ADDING MATERIALS TO THE SURFACE

Collage can be used to extend the third dimension that comes from thick impasto paint and the build-up of texture. Utilize rough edges of torn paper for petals, add patches of tissue and watch how they crumple and leach their colour when water is applied. Oil paint is a good medium for supporting materials like dried leaves or for imprinting textures. The moving force should be innovation and experimentation. Some ideas will be disastrous; others will work well.

ABOVE **Collage is used for this picture of tangled growth,** *Old Man's Beard,* **by Elisabeth Harden. The artist has used cut paper, ink, paint, tissue paper and chalk to generate this maze of ancient stems, and built up the collage by cutting up drawings, intertwining the pieces and working on the resulting image with whatever materials seemed appropriate.**

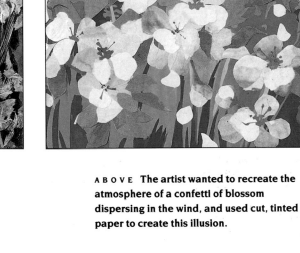

ABOVE **The artist wanted to recreate the atmosphere of a confetti of blossom dispersing in the wind, and used cut, tinted paper to create this illusion.**

DESTROYING THE IMAGE

As well as adding to an image by building up the surface, a painting can progress through destruction of the image. If, after due consideration, you feel unhappy with a gouache or watercolour, think about washing it out. Radical measures such as this require a firm heart and a strong paper – anything insubstantial might dissolve into pulp – but the result may hearten you. Stretch the washed paper on a board, or leave it to dry as it is, and work into the resulting soft colour.

Acrylics and oil paint can always be painted over, but distressing the surface by scratching or sand- papering will create textures as a base for further work, or reveal patches of tone below.

One of the exhausting elements of creating a picture is that the artist is directly responsible for the way work progresses. Introducing the chance element can be stimulating and unexpected. Perhaps a painting torn up and discarded can be reassembled. Blowing up a painting on a photocopier will give the subject a totally new character. Concentrate on a particular area of the photocopied image and see what emerges. Patterns will appear and small areas of shadow take on a large tonal identity, faint lines and details become the essential elements of structure. It is interesting to subject creative work to this mechanical process of alteration and then to return to creativity to develop the result.

What has perhaps also emerged is that this expression is not an imitation of nature but a personal interpretation – nature's impression upon the artist. Because the reality

BELOW **A discarded painting, torn up and relegated to the rubbish bin, has been resurrected and reconstructed. The artist, Shirley May, felt that fragmenting the image had given it a new life.**

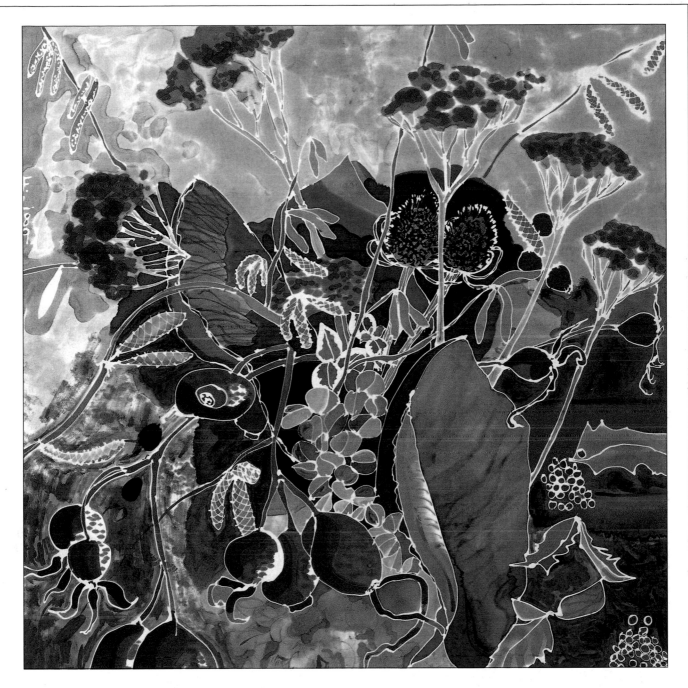

of nature is constantly changing, moving and growing, this should be the essence that we must chase. Unlike the study of buildings and, to some extent, landscape, whose reality is relatively constant, over-concentrating on the structure of the plant and trying to portray it with devout accuracy, often excludes the more important elements of spontaneity, vigour and movement.

What pleases us in the natural world is that impressions are like perfumes – fleeting and immediately evocative – like capturing a butterfly in the hands for an instant, looking and then letting it fly away. As Matisse said, "The painter must feel that he is copying nature and even when he consciously departs from nature that is only the better to interpret her."

ABOVE **This image has been painted on silk by Francesca Lucas-Clarke, using a resist medium to separate the different areas of colour. This pale outlining of form has given the catkins, flower heads and rose hips a clarity that ties their varied forms into a pleasing arrangement of colour and shape.**

TULIPS – MIXED MEDIA

ALISON MILNER GULLAND

Alison Milner Gulland works very freely, drawing an image out of an apparently haphazard mêlée of painted textures and working into this image to reveal energetic and lively plant forms. She uses a combination of printing inks, acrylic paint, acrylic medium and watercolour.

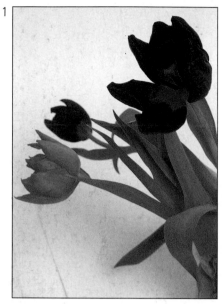

1 Brilliant red and yellow tulips are used as a basis for the composition but mainly as a source of reference rather than as a specific subject.

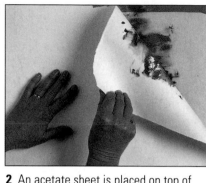

2 An acetate sheet is placed on top of white paper and used as a non-absorbent working surface on which to manipulate the colours. The artist uses printing inks, choosing whatever is appropriate from a wide collection, and manipulates them on the acetate. Diluting the ink with white spirit creates paler pools. Acrylic paint could be manipulated with water in the same way, and glass or formica would serve as a surface. A strong, smooth watercolour or printing paper is placed over the pattern of paint, pressed into the surface to move and spread the paint and then gently peeled off.

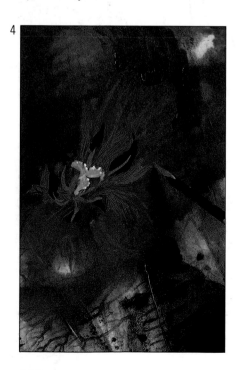

3 This monoprinting technique can be unpredictable, and success depends on experience. The resulting image is left to dry and then considered carefully to discover the flowers within.

4 Having decided how she is going to use the image, the artist draws a loose structure, using the patterns made by the monoprinted inks to construct the free shapes of the tulips. Using the live flowers as reference, she works into each flower centre with a brush to make strong marks of acrylic paint, and employs a pencil to manipulate textures.

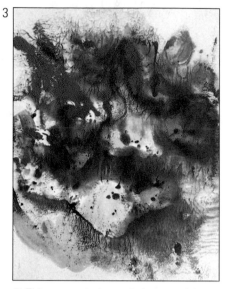

5 Dark leaf shapes are clarified and created with loose brush work. These are given texture and dimension by manipulating thick opaque paint with a palette knife.

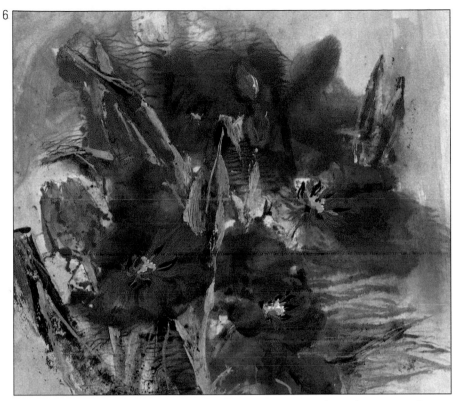

7 Two shades of blue paint are spattered onto the paper with a toothbrush and larger drops are flicked on from a brush.

6 The yellow background is extended and the shape of the leaves and the detailed flower centres give a sharpness to the composition.

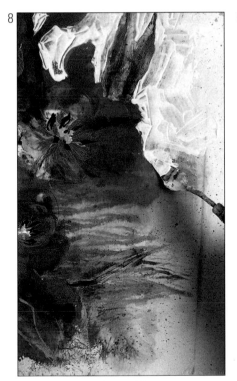

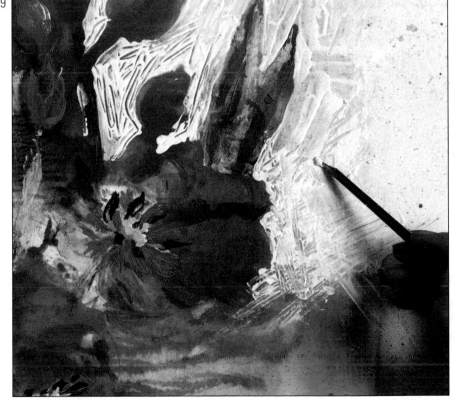

8 The artist decides at this stage to use a coat of acrylic medium to silhouette some petals and give form to the flowers in the background.

9 The artist then scrapes into the medium to give rhythm to the surface and leave a vigorous basis for further paint.

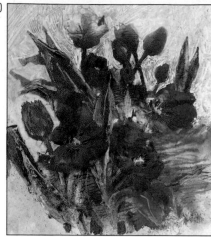

10 The blocking in of certain areas has changed the whole appearance of the composition, defining the fluid shapes of the flowers in the foreground and revealing a silhouette of shapes behind.

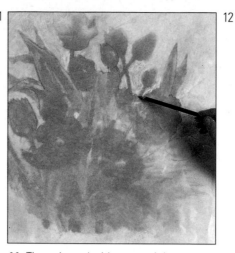

11 The painter decides to cool down certain parts. She traces the outline of the areas she wishes to remain as they are and cuts a stencil.

12 This stencil is taped in position and watercolour paint is sprayed in gentle bursts over the top half of the image with a paint diffuser.

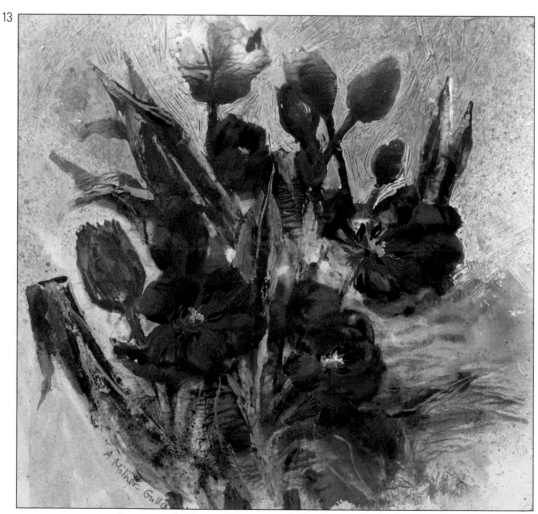

13 The final painting is a wonderful explosion of colour. The stencilling has produced areas of cool tone, and formed a background of shaded flower forms and interesting pale silhouettes.

APPROACHING YOUR WORK

Perhaps the most pressing problem which sometimes crops up for amateurs and professionals alike is an emotional one. It is the sudden loss of belief in oneself and the ability to paint. Writer's block is from the same emotional stable, an area of the subconscious that can nurture and feed an emotional flow, but will, apparently at whim, dry up.

Many painters are scared to start and require others to demonstrate or show them what to do, others put off starting to work, waiting for the ideas to come, which never do. Others are emotionally exhausted, either by painting a subject constantly or by the business of life in general. The feeling that results is very real and, at that point, very dispiriting. The right approach is vital.

So here are some positive tips on how to approach your work, thoughts on mental attitude and ideas from other artists who have experienced the same problem.

One reason for being scared to put brush to paper is the fear of the final result. Perhaps you feel you need to demonstrate your own artistic vision perfectly and the expectation of perfection is too high.

Perhaps you admire the style of another artist and want to produce your own imitation knowing it will never be the same. Nor will it – and nor should it. A painting is a particular expression of a particular artist. You have your own individual vision to develop so that it reaches its own artistic perfection – which it can.

Another factor can be too great an awareness of what you think people will want to see. Catering for a public can be a killer. Painting pleasing "pot boilers" is a means of earning money rather than a pursuit of personal vision.

> Lose this day loitering – t'will be
> The same story tomorrow – and
> The next day more dilatory.
> Then indecision brings its own delays
> And days are lost lamenting o'er lost days.
> Are you in earnest? Seize this very minute.
> What can you do or dream you can do, begin it:
> Boldness has genius, power and magic in it.
> Only imagine, then the mind grows heated.
> Begin it, then the work will be completed.
>
> **GOETHE**, *Faust*

A way of proceeding is to think of the subject, rather than thinking of you painting the subject. Let the inspiration flow from the colour and form of the flowers, allow the excitement and personality flow from them into you, rather than embarking on the project with an egoistic awareness that you are interpreting them. This way of thinking really works. Let yourself become impressionable and yielding rather than dogmatic and all-knowing.

Start work rather than think about it too much. Blank paper creates a wall. The first paint strokes will trigger off ideas, happenings along the way can be developed later. What you have painted can be thrown away if it fails, but at least you are "en route".

USEFUL TIPS

Every painter has his or her own tips – lessons learned and snippets of information accumulated that have become part of painting practice. You may well already know about some of the ideas below, but there may be some that you could add to your repertoire that could make useful contributions to the creative process.

▐ Wash brushes right up to the ferrule. Old paint accumulating in this area has a nasty habit of reappearing when least welcome.

▐ Mix enough colour; it is difficult to recreate an exact shade.

▐ Try working on two watercolours at the same time to utilize the time waiting for washes to dry.

▐ Start by painting intensely coloured flowers.

▐ Paint with other people sometimes – a collective creative atmosphere is stimulating.

▐ Visit galleries and exhibitions and take notes or make sketches to imprint ideas in your mind.

▐ Keep a means of sketching with you at all times.

▐ Use a pad of dampened newspaper, covered with smoothed greaseproof paper as a palette for acrylic paint.

▐ Make a paint chart of colours with makers' names, permanence rating and comments and keep it near the working area.

▐ If you have squeezed out too much oil paint, put it in a small jar and cover it with water for re-use later.

▐ If you are worried about the balance of a composition, turn the image upside down and see how it looks.

▐ Flowers last longer if a little lemonade is added to the water.

GLOSSARY

Alla prima A technique of painting in which only one layer of paint is applied to a surface to complete a painting.

Binder The fixative with which powdered colour is mixed.

Body colour Pigments such as gouache that have been rendered opaque by the addition of a white substance like chalk.

Collage A work put together from assembled fragments.

Contre-jour Painting against the light.

Complementary colours Colours that lie opposite each other on the colour wheel and have the effect of enhancing their opposite.

Fat Possessing a high proportion of oil to pigment.

Fugitive Applied to dyes and paints which are short lived in intensity, especially in sunlight.

Glaze Transparent film of pigment over a lighter surface or over another.

Graffito Lines produced by scratching the pigmented surface to reveal another.

Gum arabic Hardened sap of acacia trees, used as a binder and to thicken paint and add gloss.

Hot pressed paper Paper produced by the "hot pressed" method.

Impasto Paint applied thickly, so that brush and palette knife marks are evident.

Lean Paint containing little oil in proportion to pigment.

Local colour The inherent colour hue of an object.

Luminosity The effect of light appearing to come from a surface.

Medium Substance mixed with pigment to make paint; and with acrylic and oil to ease manipulation.

Negative space The space round an object, which can be used as an entity in composition.

NOT Paper with a slightly textured surface, meaning "not" hot pressed.

Precipitation The grainy effect produced when pigment separates from the medium.

Pigment Colouring matter, the basis of paints, from natural or synthetic substances.

Resist Using materials which protect a surface from the action of paint; paper, masking tape and masking fluid all fulfil this purpose.

Saturation The strongest possible concentration of pigment.

Tone The gradation of light to dark.

Tooth Texture or roughness of paper or canvas, allowing paint to grip the surface.

BIBLIOGRAPHY

Blunt, Wilfrid, with the assistance of William Stearn. *The Art of Botanical Illustration*, London, William Collins, 1967

Foshay, Ella M. *Reflections of Nature: Flowers in American Art*, New York, Alfred A. Knopf, Inc., 1984

Harrison, Hazel. *The Encyclopedia of Watercolour Techniques*, London, Quarto Publishing, 1990

Hulton, Paul, and Smith, Lawrence. *Flowers in Art from East and West*, London, British Museum Publications, 1979

Martin, Judy. *Drawing with Colour*, London, Studio Vista, 1989

Mayer, Ralph. *The Artist's Handbook of Materials and Techniques*, London, Faber & Faber, 1951

Mitchell, Peter. *European Flower Painters*, London, A. & C. Black, 1973

Riley, Paul. *Flower Painting*, Shaftesbury, Broadcast Books, 1990

Russell, John. *Jennifer Bartlett: In the Garden*, New York, Harry N. Abrams, 1992

West, Keith. *How to Draw Plants*, London, The Herbert Press, 1983

INDEX

Italic page numbers refer to picture captions.

A

acrylics 117, 118
 materials and equipment 21, *21*, 24
 techniques 29, 34, 74
alla prima technique 34, *35*
ambiguity *100*
Arts and Crafts Movement 11
assessing and finishing 75, *79*
atmosphere 98, *98, 99*

B

back runs 26, *26*
backgrounds 67, *67, 83,* 102–13, *43*
 oils *68*
 watercolour 30, *38, 48, 56*
bleach 56
brushes 11, *13,* 15, 23, *23*
 acrylics 15, *19,* 21, 24
 Chinese 15, *19, 94*
 hog hair 23, *23*
 oils 23, *23,* 24
 sizing 15
 toothbrush 20, 29, *29, 123*
 watercolour 15, *15–17, 19,* 24, 26

C

candlelight *96*
canvas 24
Cézanne, Paul 64
cleaning up 24
collage 119, *119*
colour 80–92, 93
 and composition 63, *63,* 66, *66, 72,* 91, *91*
 hue and tone 84, *84*
 saturation 84
 two-colour brush-strokes 30, *30,* 46
colour wheel 22, 81–2, *82*
complementary colours *72,* 81–2, *81, 82, 83*
composition *57,* 62–79, 91, *91,* 100
 pictures in a setting 102–13
containers, flower 65
copying works by other artists 56, *57*
crayons, watersoluble 14, *48–51, 54,* 118

D

dry brush technique 26, *26,* 46
Dürer, Albrecht 9, *9*

F

Fauvism 81
flower structure 45–7
focal point 72, 104
frottage 35
fugitive colours 14

G

glass, painting *50,* 65
glazing 34, 35

gouache
gouache *14, 48–51, 55, 99, 103, 104, 105–8, 111, 112,* 117, *117*
 brushes 15, *15–17, 19*
 materials and equipment 12, 13–20, *13*
 paper 18–19, *19*
 techniques 14, 29, 31–3
gum arabic 13, *13,* 26, 31

H

hairdryer 20, 26, *26, 29, 61*
hard edges 27, *27, 29,* 34, *61*
history of flower painting 8–11, 88

I

impasto 14, 24, 46, 119
Impressionism *10,* 11, 34, *35, 57,* 67, 81, 98, *98*
indentation technique 28, *28*
inks 14, 31, *32–3, 54*
interiors 103–4

L

landscapes 109–12, *109–13*
leaves 44, *44*
Leonardo da Vinci 9
lifting out 27
lighting 24, 67, 93–101
line, fluidity 56
lines of movement 72, *72*

M

Mackintosh, Charles Rennie 11, *56*
Manet, Edouard 98
masking 34, *43, 85, 87*
 masking fluid *13,* 28, *28, 29, 39–41, 85, 87, 92, 106–7*
Matisse, Henri 47, 121
mixed media 117–18, *122–4*
Monet, Claude 11, 98
Monnoyer, Jean Baptiste *10*
monoprints *122–4*

N

negative shapes *61,* 75, *75, 76*

O

oil pastels 31, 118
oils 12, *68–71,* 117, 119
 materials and equipment 22–4, *23*
 in stick form 23, 35
 techniques 29, 34–5, *35,* 74
O'Keeffe, Georgia 112
ox gall 26

P

palette *19,* 20, 22, 24
palette knife 22, *35, 70–1*
paper 18–19, *19*
 buckling 60
 stretching *20*
pastels 117, *117*

pattern 31, 100, *100, 101,* 104
pen and wash 18, *54*
permanence, colour 14
plant structure 36–51
Post-Impressionism 81
Pre-Raphaelites 11
primary colours 81, *81, 82*

R

Redon, Odilon 11, *11*
Redoute 11
Renoir, Pierre-August *10, 11,* 98

S

salt, watercolour technique 31
saturated colour 100
scraping and scratching 29, 120, *123*
scumbling 35, *69*
shadow 84, 94, 100, *100, 101,* 104
silhouettes *38,* 118, *123–4*
silk, painting on *121*
sketching 52–61
 and composition 73, *73,* 75
 materials 58
 thumbnail 73, *73, 76*
spattering 29, *29,* 46, *107, 123*
speckling 31
sponge 20, 29
stems 43, *43, 49*
stencilling 31, *124*
supports 21, 24. *See also* paper

T

texture 31, 43, 44, 46, *55, 70*
thumbnail sketches 73, *73, 76*
tone 73, *73,* 84, *84*
Toulouse Lautrec, Henri 100
Turner, J.M.W. 98

V

Van Gogh, Vincent 11, 63
viewfinder 72, *85,* 103, 104

W

washes 30
washing-out 31, *32–3,* 120
watercolour 115, 117
 brushes 15, *15–17, 19,* 24, 26
 fugitive colours 14
 granulation 13
 hard and soft edges 27, *27, 29, 61*
 liquid 14
 materials and equipment 12, 13–20, *13*
 paper 18–19, *19*
 staining power 14
 techniques 26–31, 74
 white areas *13*
wax resist 31, *31,* 118
wet-on-wet technique 30, *40, 60–1,* 110
white flowers 92, *92*
work place 24, 75